P
it

The Complete Guide to

PAINTING AND DECORATING PORCELAIN

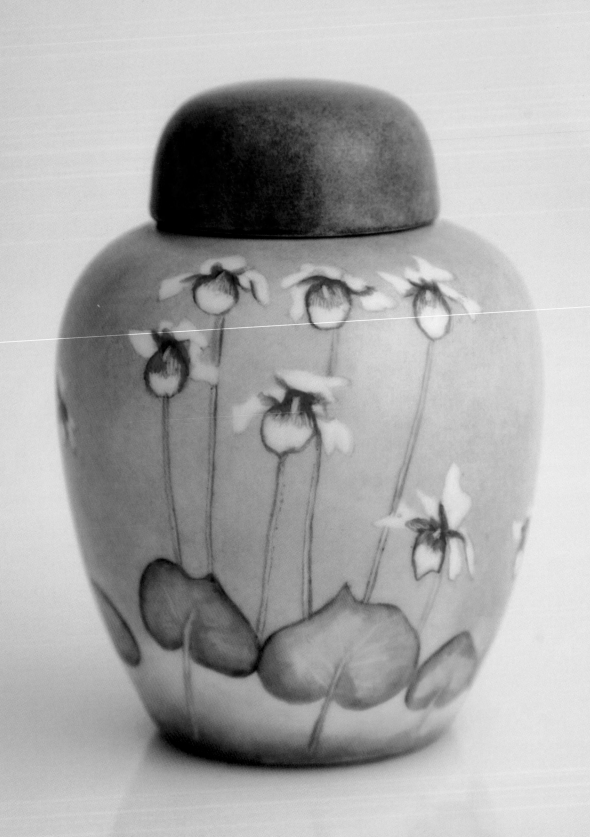

The Complete Guide to

PAINTING AND DECORATING PORCELAIN

PATRICIA NEWELL-DUNKLEY

Robert Hale • London

© Patricia Newell-Dunkley 2009
First published in Great Britain 2009

ISBN 978 0 7090 8649 9

Robert Hale Limited
Clerkenwell House
Clerkenwell Green
London EC1R 0HT

www.halebooks.com

A catalogue record for this book is available from the British Library

2 4 6 8 10 9 7 5 3 1

Design by Judy Linard
Printed by Kyodo Nation Printing Services Co. Ltd, Thailand

CONTENTS

List of photographs and illustrations with text 7

Foreword 9

Introduction: History and techniques 11

1 Basic rules and methods 29

2 Loading and firing 38

3 Grounding and more about kiln work 42

4 Lustres and firing 48

5 Raised paste – description and materials 57

6 Gold and silver: forms and application 66

7 General overview of subjects to paint and design 76

8 Pen work 90

9 Portrait painting on porcelain 92

10 Landscape painting 106

11 Cats and dogs 123

12 Birds 138

13 Blue and white porcelain 149

14 Techniques of fruit painting 156

Appendix 171

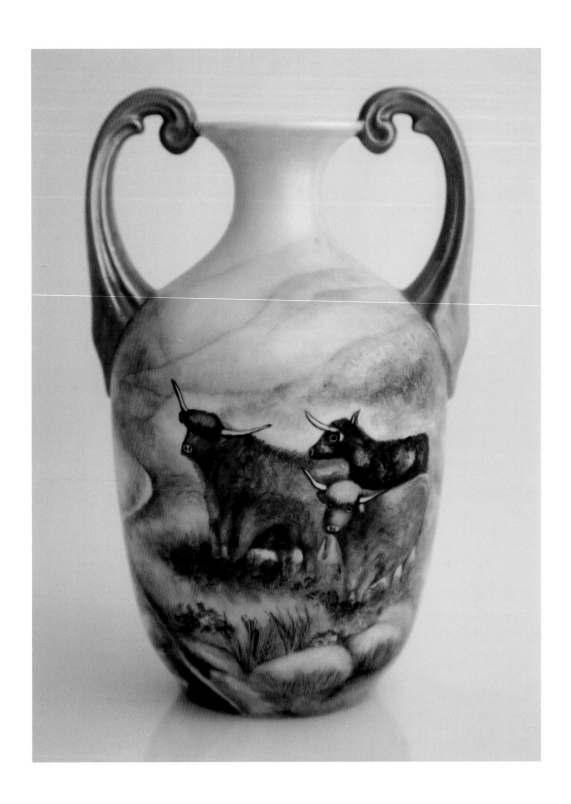

LIST OF PHOTOGRAPHS AND ILLUSTRATIONS WITH TEXT

1	Bone china round trinket box	14
2	Small round porcelain trinket box	17
3	Pair of small porcelain ginger jars	19
4	Porcelain plate with pansies	21
5	Cylinder porcelain vase with open poppies	22
6	Matching plate for cylinder vase with poppies	23
7	Two-handled porcelain vase with pink roses	25
8	Happy Plate series with sailing boats	35
9	Happy Plate series with man walking dog	36
10	Oval porcelain trinket box with magenta ground	39
11	Oval porcelain trinket box with Rose du Barry ground	39
12	Happy Plate series with yellow and blue trees	45
13	Happy Plate series with pink umbrella	46
14 & 15	Matching pair of Furstenburg porcelain vases	50-1
16	Copper lustre fancy lattice plate	52
17	Copper lustre decorative ribbon plate	53
18	Original design of small porcelain plate with dark blue fancy ground	58
19	Original design of small porcelain plate with swirl of maroon ground	59
20	Silver lidded white porcelain ginger jar	61
21	Silver lidded white porcelain ginger jar with patterned raised paste design	62
22	Superb porcelain plate designed and hand-painted with dark blue ground	64
23	Matching forget-me-nots six-medallion bracelet, ring and brooch	70
24	Matching white and green daisies eight-medallion bracelet, ring and brooch	73

25	Matching violets seven-medallion bracelet, ring and brooch	75
26	Yellow porcelain teapot	78
27	Cup and saucer with light red ground cup and bell flower design saucer	84
28	Cup and saucer with celadon ground colour	85
29	Small round trinket box with four-leaf-clover design	87
30	Hand-painted plate with 'Sicilian Girl'	93
31	Hand-painted plate with portrait of 'his daughter' after Constable	94
32	Large plaque of hand-painted portrait of an Edwardian Lady	95
33	Hand-painted fancy plate	96
34	Hand-painted plate with portrait of girl	99
35	Hand-painted plate with portrait of girl with green eyes	102
36	Hand-painted plate of laughing boy	104
37	Hand-painted plate of laughing girl	105
38	Kaiser porcelain vase	107
39	Large porcelain vase with Highland Cattle scene	110
40	Small porcelain vase with Highland Cattle scene. Front	110
41	Small porcelain vase with Highland Cattle scene. Back.	110
42	Garniture of three handled porcelain vases	111
43	Happy Plate series with yellow and bright red tree	115
44	Happy Plate series with yellow tree and sailing boats	119
45	Happy Plate series with turquoise and pink trees	120
46	Medium-size porcelain plate with Siamese black cat	125
47	Medium-size porcelain plate with yellow and black fluffy cat	126
48	Medium-size porcelain plate with cat with green eyes	127
49	Medium-size porcelain plate with yellow cat	128
50	Medium-size porcelain plate with distinctive black and yellow striped cat	129
51	Black and white pen oval plate with Cocker Spaniel	133
52	Cylinder porcelain vase with robin and sparrow	141
53	Back of cylinder vase with thrush in snow setting	142
54 & 55	A superb pair of German porcelain lidded jars	144-5
56 & 57	Matching green and black exotic bird	146-7
58	Hand-painted plate of Winston Churchill	153
59	Small fine porcelain bottle with blue ground. Front.	159
60	Small fine porcelain bottle with blue ground. Back.	159
61	Furstenburg porcelain pedestal vase	160
62	Freehand-painted fruit plate	162
63	Finely painted porcelain plate with red apples and white grapes	163
64	Large Kaiser porcelain vase with freehand-painted fruit	166
65	Back of large Kaiser porcelain vase	167
66	Round bone china trinket box	169
67	Happy Plate series with beach scene	172

FOREWORD

Recently, I had the great joy of making my first visit to Australia, and met an old friend – Patricia Newell-Dunkley – again. I was very impressed with her china-painting and the classes she taught, and happily agreed to write the foreword to her book.

Ceramic painting is a wonderful and ancient craft. Whether on pottery, porcelain or bone china, the atmospheric underglaze cobalt oxides and the glowing onglaze metallic oxides never fail to lift the heart. There is something magical about the dull, raw colours entering the kiln and emerging in their full glory after the firing. Surely only a factory-trained artist could accomplish this, one might think?

Amateur china-painting has been carried on for several hundred years. Geoffrey Gooden, in his fine book *Chamberlain: Worcester Porcelain* quotes from the factory records of June 1806 –

Prince Bariatinsky, Cheltenham

A complete set of colours	£ 1- 1s-0d
Pencils, oils, knives	£ 8s-0d
A batch of Bronzes	£ 10s-0d
Regilding a plate and 3 candlesticks	£ 19s-0d
Eight lessons in painting	£ 6-16s-6d
Expenses to Cheltenham	£ 5-16s-6d

From Patricia's book, you will know that 'pencils' are brushes and bronzes are bronze colours, and you will also learn to do the gilding so that you will not need to pay 19 shillings to have poor gilding done again, as Prince Bariatinsky did. I wonder where the Prince's proudly painted pieces are now?

By the Victorian period china-painting at home had become a lady-like pursuit, and you could enter your work in selling exhibitions like Howell and James in London. Such pieces would be signed and dated under the base and carry Howell and James' label. It fascinates people when they bring such a piece into the BBC *Antiques Roadshow* to be told that the work must be by a gifted amateur, as the factories would not allow their painters to sign or date their work. Also you could point out the lack of years of training shown by poor perspective with no space behind objects, making it look as if things were stuck together.

By the twentieth century, a large number of china painting clubs had started up all round the world. I am patron of a number of them, and trained ex-painters of such factories as Royal Worcester spend a great amount of their time in visiting and training such groups. It is exciting to visit the regular exhibitions and see the ever-growing quality of such work. If you have ever had the urge to do such a thing, there is no better time than the present and this new book could be the spur.

Patricia takes you by the hand and leads you knowledgably through all the processes. Even if you only want to make a birthday or Christmas present for a friend or aim higher and produce a precious antique to be taken into a future *Antiques Roadshow*, you will find all the help you need in this book. The nitty-gritty is interwoven with stories about the history of styles and patterns, and I picture a keen student reading the book with one hand and studiously applying the brush to the tile or vase with the other. Everything is put into simple sequences with constant urging to keep the ceramic blank scrupulously clean, and if you follow everything carefully you should not fail.

I wish you all the best and perhaps one day I shall see the results.

HENRY SANDON

INTRODUCTION:
HISTORY AND TECHNIQUES

Painting on porcelain is an extremely old art form and one that is very well suited to those people who have no ability to draw, as well as to those who do. Once you have mastered the necessary skill needed to paint on porcelain, you can then decide which type of decoration is best suited to your own ability. It is more the artistic and harmonious end result which is important, rather than the manner in which you achieve it.

This intricate and beautiful handcraft can introduce beginners to working with brush and paint, in such a way that they can ultimately surge forward and move on to other mediums, such as watercolour and oil painting, with relative ease.

This was the case with Pierre-Auguste Renoir, who at the age of thirteen was employed by a china manufacturer in the town of Limoges, to paint sprays of flowers on smooth white porcelain. During his four-year apprenticeship he was taught a disciplined use of the brush, a fine touch and an appreciation of colour on a white ground – excellent training for any art form.

There are many styles of painting on porcelain, beginning with the Conventional, the Naturalistic, the Soft Look and the Wipe Out methods. Then there are the distinctive nationalistic styles: the Kellinghusen of Denmark, the Bindstue from Sweden, Norway or Finland, and the Oriental. Finally, there are the more familiar European styles from institutions such as

Meissen, Sèvres, Dresden, Worcester, Doulton, Derby and Wedgwood. They all involve the same procedure: the mixing of mineral oxide paint with a suitable medium, and then applying it over the glazed porcelain. When the piece is fired in the kiln, the pores of the porcelain open up and the colour is fused with the glaze. Depth of colour is achieved by consecutive thin layers of paint, and subsequent firing after each application.

This is called on-glaze painting and is not to be confused with underglaze painting, which is quite different. Here the artist works on bisque ware in its unglazed condition, and it can be in varying colours from white to brick-red. The surface is absorbent and porous, and easy to sketch on before it is finally dipped into a creamy glaze rendering it shiny and permanent.

In my home country of Australia we have been fortunate in having the opportunity of learning various styles and techniques during our short history.

With the first settlement of migrants to Australia, the freelance painting of porcelain was strictly for the wealthy and practised in the English tradition. Genteel ladies would pursue this art form for relaxation. In the early 1900s the Society of Arts and Crafts of New South Wales included China painting in their curriculum and there was a steady following of the art form. The National School of Australian Applied Art and Design was formed in 1906, and students at technical colleges were encouraged to use native flora for design and form on porcelain. They concentrated on the Waratah, recognized as the leading flower in Australian applied art. It has figured in almost all branches of the liberal arts and sciences dating from the Colony's foundation. Louis Bilton, the foremost ceramic artist at Royal Doulton Potteries, was sent to Australia in the 1880s to paint from living specimens, using the magnificent Waratah as his principal subject.

During this time the masterful Australian watercolourist Ellis Rowan was commissioned to make many designs for the Royal Worcester Porcelain Company, and Australian wild flowers were among the most popular. Such eminent Worcester artists as Reginald Austin, Louise Flexman, George Johnson, Ernest Phillips, Albert Shuck and William Taylor reproduced her

exquisite studies. Some of the hand-painted Worcester porcelain, together with pieces from Doulton by Louis Bilton and Katherine Smallfield, Golden Wattle by Arthur Holland from Wedgwood, and conventionalized Waratah designs painted by Olive E. Nock from Aynsley, were ultimately returned to Australia and sold in Sydney, Melbourne and Adelaide. Today they are collectors' pieces and much sought after.

In the middle of the twentieth century, with the influx of post-World War II migrants to Australia, all this changed and we were in the unique position of becoming a melting pot for multi-talented ceramic artists who settled in the country. Painters who had been professionally taught in well-known studio-factories around the world were only too happy to pass on their knowledge. Consequently, the face of porcelain painting in Australia altered, in both style and availability.

This phenomenon had also happened in America under similar circum-stances, during the surge in immigration of the late 1880s. Franz A. Bischoff and Franz Aulich, both from Austria, were prominent in this period. They were equally famous for their superb painting of roses and grapes, executed with unrivalled technical skill in a broad impressionistic watercolour style. Also notable in this period was D. M. Campana from Italy, whose work was mainly pictorial. Human figures and faces were his favourites, depicted in the manner of oil painting on canvas. There were many others who established themselves in the New World and were responsible for advancing porcelain painting to the highest state of art, and in the USA these pioneers in the field taught extensively, passing on their knowledge to eager pupils. At the Chicago World's Fair of 1893, gold medals and blue ribbons were quickly achieved by these talented teachers and their pupils. As a result the art form flourished.

In Sydney, Australia, during the early 1960s – the time when I started porcelain painting – there was a massive revival in the art form. Ceramic artists had by now established themselves. Teaching studios flourished, and seminars were held for all aspects of painting on porcelain, with specialized teachers invited from the USA, Switzerland, Britain, Spain and New Zealand. It wasn't long before all Australian states had enthusiastic devotees of the art,

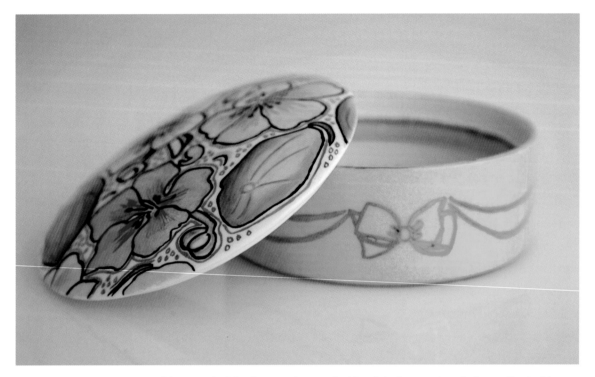

Bone china round trinket box, top decorated with original nasturtium design outlined with liquid bright gold. Bottom of box egg yellow ground with liquid bright gold ribbon and bows, and lined with yellow silk and velvet ribbon.

in much the same way as had happened in America. There was a great deal of friendly rivalry as to which method was the 'best'. Most students were able to buy their own kilns and everyone benefited from the multi-knowledge that was generously offered as a result.

It was an exciting period, and during this time the art form constantly strove to be recognized as a fine art, with a degree. This it has now become under the auspices of the University of New South Wales and the NSW Teaching Institute of Porcelain Art.

Material used

It is always a good idea to know as much as possible about the material you are using for your particular art work. For instance, with watercolours, what

weight and texture of paper is best, and does the paper bleed when coloured inks are applied? Also, how do particular watercolours respond to various types of paper, and what degree of fading can you expect? With pastels, which side of the paper will give you the best result – the smooth or the textured? Do you want to spray your work and perhaps alter the look of the colours?

When using oil paints or acrylics, you have to know the weave of your canvas. Is it 100 per cent cotton? Does it have an acid-free surface? How many times has it been primed? When do you varnish the finished work?

All of this knowledge is invaluable, and so it is in the case of the porcelain painter, whose chief advantage over all other modes of painting is that once the mineral oxide paint is fired on to the porcelain the colours are imperishable. With no other pigments are you able to obtain such brightness and beautiful results, so transparent, true and glowing as they appear in all their tones. Heat, cold or dampness cannot affect the lasting creation of a work of art on porcelain, and it is one that requires no further attention other than tender loving care.

In the past, articles such as vases and figures were made by casting in plaster moulds, while cups, plates, bowls, etc., were made by a process called 'turning'. Today, continuously operated pressing machines make the required porcelain shapes on sophisticated equipment, eliminating the past drudgery of factory work. Wheel-thrown wares are still made, but to a lesser degree.

Little wonder that the discovery of making porcelain caused such excitement in the 1700s, when a genuine hard-paste porcelain was successfully produced at Meissen in Germany by Ehrenfried Walther von Tschirnhaus, though Johann Friedrich Bottger has also been credited with the invention. The recipe was kept secret, and experiments continued elsewhere as other manufacturers were desperate to catch up with Meissen. It was a highly charged situation with much to be gained by the production of true porcelain. There are stories of men hiding in barrels with peep-holes to observe the mixing of porcelain, kidnapping with threats to life, and Chinese laundry baskets being smuggled away with suspicious contents. Big money changed

hands for a chance of obtaining the correct recipe. It was a time of closely guarded secrets in real 007 style.

Up until the 1700s China had been the envy of the world as she exported exquisite works of art on equally brilliant porcelain, executed in the Chinese taste, before the fourteenth century. Imperial pieces, large Imari chargers (large flat dishes) in *verte* (green) and *famille rose* (pink), Chinese lions, exotic vases, wine coolers, tea sets – there was no end to their versatility in the making of china ware (the term used for porcelain manufacture). Attempts were made to imitate it from the fifteenth century onwards, but its composition was not understood. Because of its translucency it was thought that glass might be an ingredient, so many experiments were carried out including clay with powdered glass (known as 'frit'). In the late sixteenth century in Florence, under the patronage of the Medicis, there were trials using opaque glass alone, but to no avail.

Many thanks are due to two extremely clever alchemists of that period, Messrs Tschirnhaus and Bottger, for their perseverance and ultimate discovery of the necessary ingredients to form porcelain, ultimately enabling other manufacturers to do likewise despite attempts to keep it secret. The process spread to other German ceramic factories and eventually to the rest of Europe. This precious material is not only employed for objects of fine art and tiles, it is also used for table, kitchen, sanitary and decorative wares, as well as insulating material for high-voltage electricity. It is also an invaluable aid in dentistry, making false teeth, caps and crowns; and where, of course, would we be without our porcelain teapot!

Porcelain was named after its resemblance to the white shiny cowry shell, called *porcella* (little pig) in old Italian because the curved shape of its upper surface resembles the curve of a pig's back. The properties associated with porcelain include low permeability, high strength, hardness, glassiness, high durability, whiteness, translucence, resonance, brittleness, high resistance to the passage of electricity, high resistance to chemical attack, high resistance to thermal shock and high elasticity. It is a truly remarkable product, and one which can literally fly you to the moon. Six space shuttles have been built over

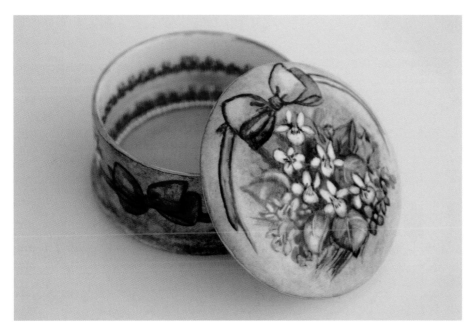

Small round porcelain trinket box, top decorated with scattered violets and ribbon bow. Bottom of box ground in purple, and lined with lilac silk, gold braid and pearls, the outside with hand-painted bows.

the years, with thousands of heat-resistant ceramic tiles to protect its exterior from overheating due to the friction generated by the earth's atmosphere. The history of porcelain continues dramatically, as NASA has announced that in the near future a new vehicle named Orion will be available to take humans to the moon and beyond.

For the on-glaze porcelain artist for whom this book is written, there are three types of porcelain available:

- *Hard-paste porcelain*, which was originally made from a compound of the feldspathic rock petuntse and kaolin, and fired at a very high temperature. It was first made in China around the ninth century. Today, hard-paste (or just 'hard') porcelain is a mixture of kaolin, feldspar and quartz. Other raw materials can also be used and these include porcelain and pottery stones. These are the same as petuntse, but this name has long fallen out of use. Hard-paste is now differentiated from soft-paste

porcelain mainly by the firing temperature, with the former being to around 1,400°C and the latter to around 1,200°C. Depending on the raw materials and firing methods used, hard-paste porcelain can also resemble stoneware or earthenware. Hard-paste porcelain can be utilized to make porcelain bisque, a particularly hard type of porcelain. It is a translucent and bright, white ceramic. With it being almost impermeable to water it is unnecessary to glaze the body. Manufacturers using hard-paste porcelain for their statuettes include Lladro, Hummel and Precious Moments.

- *Bone china* is a type of porcelain body first developed in Britain in which calcined ox bone (bone ash) is a major ingredient, and this greatly increases the translucence of the porcelain. It is characterized by high whiteness, translucency and strength; although not as hard as true porcelain, it is more durable than soft-paste porcelain. The production requires a two-stage firing where the first – bisque – is without a glaze at 1,280°C, giving a translucent product. You then glaze, or glost, and fire at a lower temperature below 1,080°C. English manufacturers were keen to produce porcelain of the quality to be found in Chinese imports, but they had to go down a different route. William Cookworthy is credited with discovering china clay in Cornwall which made a considerable contribution to the development of porcelain and other whiteware ceramics in the United Kingdom. Cookworthy's factory at Plymouth, established in 1768, used Cornish china clay and Cornish china stone to make a form of porcelain, the body of which closely resembled the Chinese porcelains of the early eighteenth century in character. The first use of bone ash in ceramics is attributed to Thomas Frye, who in 1748 made a type of soft-paste porcelain at his Bow China Works. In the late eighteenth century, Josiah Spode undertook further developments, and subsequently popularized this porcelain by mixing it with china clay, kaolin and china stone to compete with the imported Oriental porcelain. England still produces nearly all of the world's bone china.

- *Soft-paste porcelain* is a type of ceramic material, but it lacks a more

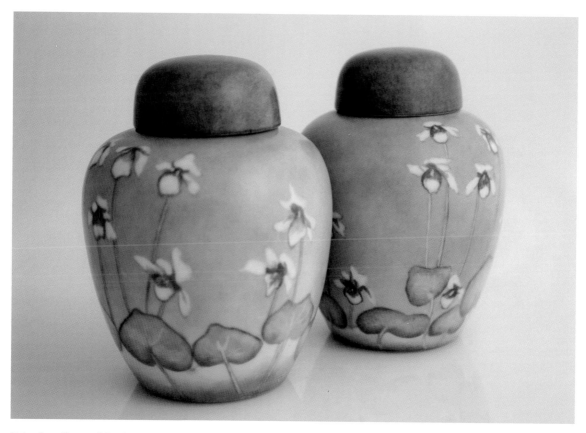

Pair of small porcelain ginger jars with violet of gold lids and background of lavender enamel colour, with freehand design of wood violets and leaves, pulled out of semi-dried background for effect.

specific, universally agreed definition. Some writers have used the term for body formulations that combine clay and glass frit, mainly in the production of decorative figures and domestic wares in eighteenth-century Europe, while others have used the term more widely to include other soft porcelains as well, such as bone china, Segar porcelain, vitreous porcelain, new Sèvres porcelain, Parian porcelain and soft feldspathic porcelain. Soft-paste is fired at lower temperatures than hard-paste porcelain, around 1,100°C for the frit-based compositions and 1,200 to 1,250°C for those using feldspars or nepheline syenites as the primary flux. The lower firing temperature gives artists and manufacturers some benefits, including a wider palette of colours for decoration and reduced

fuel consumption. The body of soft-paste is more granular than hard-paste porcelain, less glass being formed in the firing process. The surface takes well to enamelled decoration, added after the glaze firing, especially in the case of figurines, and this has been much admired by buyers, collectors and art historians.

There are many manufacturers of porcelain around the world, hard-paste, bone china, and soft-paste, each having their own particular recipe for the article they are offering. The availability of choice for decorators used to be dictated by their supplier and where they are situated. However, today most china-ware painting shops carry a large and varied stock, with English, European and Japanese pieces readily available. Some retailers specialize in carrying certain popular shapes, such as ginger jars, classic vases, plaques, tiles, medallions for jewellery, elegant lidded boxes, egg shapes, cups and saucers, tea and coffee pots, fancy ribbon and lace plates, and simple plates of all sizes. There are some very decorative Japanese pieces on the market, including animals, birds and figurines; each will be specified as to which type of porcelain it is and this will have a bearing on the firing. Shapes of porcelain constantly change; however, some names are very recognizable: Worcester, Doulton, Arzberg, Kaiser, Furstenberg (a company still using their 1747 moulds), Meissen, Limoges Boxes and Limoges have been around a long time, with a good history. Not all of the English bone china manufacturers cater for the decorator, but there are many available brands on the market, depending on your supplier. Make sure that the distinctive sign of the company appears on the bottom of the piece as this will add value to your end product.

- Bone china has a lower firing, 750–780°C.
- Hard porcelain takes a high firing, 800–850°C.

Most decorator pieces are usually of porcelain or bone china. Soft-paste is not widely used for blanks. For the beginner artist, I suggest you stay with

one or the other type of porcelain named until you are familiar with your ware and how it works for you.

When purchasing your porcelain make sure that the surface is perfect, and that there are no holes or black marks, minute blisters or bubbles in the glaze visible to the eye. These faults can ruin a fine piece of art work, causing spitting in the kiln, and will show up through the colour. The glaze must be even and faultless. Remember, always, that what you see is what you get!

Fragrant flowers in art

The representation of flowers in art has a long and fascinating history, not only for their visual beauty, which alone is stunning, but also for their symbolic importance. Sandro Botticelli's painting *Primavera*, c. 1482, has a profusion of flowers scattered throughout the composition, both carpeting and canopying the work with glorious highlights of colour. One's eyes are bewitched, as they travel over the canvas, by the bright flecks of the flowers – pink carnations, blue periwinkles, white and yellow daisies, blushing pink roses, bright red poppies and purple iris. At the last count, five hundred flowers and plants of the period adorn the orange grove and the

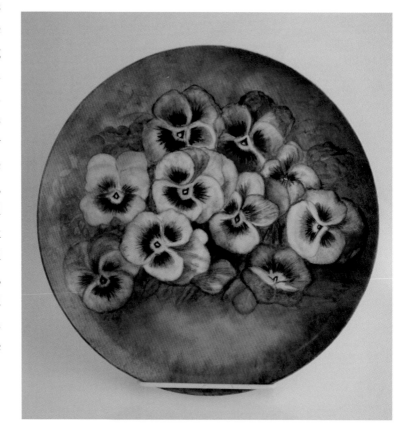

Porcelain plate with freehand painting of shower of pansies in woodland setting.

Cylinder porcelain vase with freely painted open poppies in light red, with muted lemon-yellow and apple green background and gold rim.

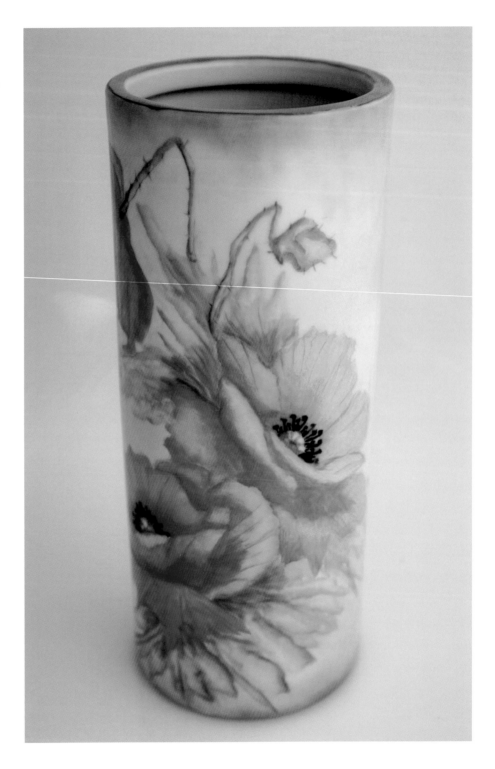

perfume of the blossom is heady.

Everything in the painting breathes lushness. There is the diaphanous clothing worn by the Three Graces, with their slightly elongated bodies, while Venus, the goddess of love, stands centre-stage, framed by an array of foliage as she heralds the arrival of spring. Flora, the goddess of spring, stands alongside Venus dressed in a flowing gown of multi-coloured floral material, and scatters more flowers and petals. Without the added floral fantasy, this magnificent 7 ft by 10 ft painting would not have the

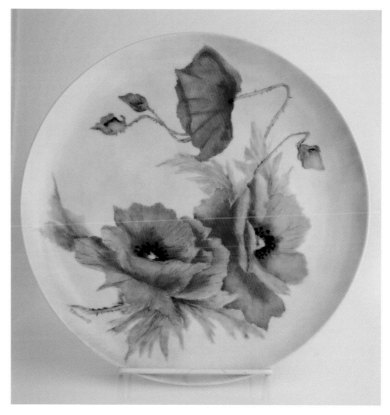

Matching plate for cylinder vase with hand-painted open red poppies, with muted lemon-yellow and green background.

same universal appeal. Botticelli would have realized this when he stood back and gazed at his canvas before harmonizing it with blooms.

Primavera means the arrival of spring and flowers, with their symbolic presence of divine love. Botticelli conceived that such a painting as this was the perfect gift for the young couple about to wed. He painted his masterpiece in egg tempera – hence the creamy look throughout – on a wooden panel, and it now hangs in the Uffizi, in Florence. The flowers still sparkle and set the painting alive with their message of beauty and adornment.

In the fifteenth century Albrecht Dürer soared the humble violet to fame with his painting *A Bouquet of Violets*. This captivating watercolour of a small bunch of violets within a halo of their own green leaves is full of sentimen-

23

tality. Violets are associated with virtues such as modesty, faith and love, and continue to appear in all forms of decoration to this day. For the porcelain painter the violet is a perfect flower enhancing any work of art, whether it is in the form of a posy or delicately trailing among other small flowers. Its appearance brings a touch of refinement and Old World charm. These tiny purple flowers are full of fragrance and much in demand for their perfume, as are their vibrant green leaves, which are crushed and used for essence.

In the sixteenth and seventeenth centuries Dutch flower painting became extremely fashionable as celebrated artists turned their talents to portraying exotic and rare flowers in bountiful array. This was the highest paid and most revered art form of the period, and flower painters produced imaginative bouquets with blooms that were both in and out of season, sometimes taking more than twelve months to finish a canvas. Full-blown roses, scarlet lilies, fritillaries, exquisite sprays of lily-of-the-valley, hyacinths, hollyhocks, carnations and daffodils ... but the star was the multi-coloured tulip. Beautifully painted blossoms spilled over vases in all their beauty, and every home-owner yearned to possess a still life painting with flowers as its theme. These works of art were considered the ultimate possession.

This was to become the era known as tulipmania, the height of Dutch flower painting when tulip bulbs were auctioned for more money than the most expensive houses in Amsterdam, a bewildering time when passion for flowers overpowered sanity and religious ideals were linked with pictorial visions.

One of the most celebrated artists of the time was Rachel Ruysch of Amsterdam, who was a successful floral specialist for seventy years. A member of the painters' guild in The Hague, she produced large flower pieces for a prominent clientele and also served as court painter to Johann Wilhelm, the Elector Palatine of Bavaria, for eight years. Although this talented lady was married for fifty years to the portrait painter Juriaen Pool and together they produced a family of ten children, Rachel continued painting until her death.

The Fitzwilliam Museum in Cambridge houses a wonderful collection of flower and still life paintings. Here you will find glorious works by Jan Brueghel the Elder, Melanie de Comolera, Paulus Theodorus van Brussel, Jan

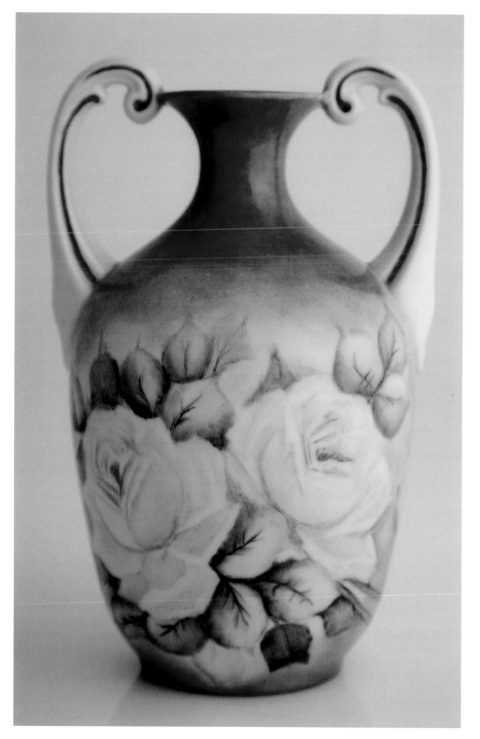

Two-handled porcelain vase softly painted with pink roses on a deep magenta background, white handles picked out with magenta.

Van Os and many others, including a glorious Rachel Ruysch featuring hibiscus and an assortment of flowers plus two glistening peaches. The Fitzwilliam is the foremost repository of flower paintings in Britain and well worth a visit by any art enthusiast.

In the Victorian era, cottage gardens were all the rage, with massed flowers crammed into small gardens, and herbaceous borders of riotous colour including pinks, sweet williams, wallflowers, primroses, rockets, stocks, sweet peas, pansies, phlox, asters, carnations, delphiniums and hollyhocks, together with climbing roses and sunflowers. Arthur Strachen, Beatrice Parsons, Theresa Stannard, Helen Allingham and David Woodlock all show these flowers in the watercolour paintings of the time, with a pretty thatched cottage nestled in the background.

Not only were flowers planted, painted and plucked, they appeared in all forms of literature. Poets of the time gilded the lily, as the saying goes, and floral illustrations accompanied all forms of writing, including works on the meaning of flowers.

Meanwhile, tucked away in a Victorian building within the confines of the Royal Botanical Gardens in Kew is the noted Marianne North Gallery. This is a treasure-house of the most glorious botanical paintings from all around the world, 832 in all, which are hung edge to edge, creating a kaleidoscope of colour as you enter. With the lower parts of the walls clad in 246 different types of wood, which the artist collected during her travels, the gallery is one of the most unique in the world.

This intrepid lady travelled the globe for thirteen years, painting on location at a time when most Victorian ladies were expected to stay at home and raise a family. The legacy she has left is priceless, as many of the painted species have sadly disappeared. Not only did she donate the paintings but also the building in which to house them. Visitors from around the world can recognize their own particular native flower or landscape, and feel connected when viewing the wonders of nature's creation as shown by Marianne North. A walk through Kew Gardens in bluebell time and a visit to the enchanted gallery brings the meaning of flowers in art to a new dimension.

The styles and techniques of painting in ceramic art have changed dramatically over the years, but the pursuit of the perfect flower reproduction on porcelain has always played a major role and continues to do so. There have been many extremely talented ceramic floral artists in the past – names such as William Billingsley, famous for his naturalistic style painted directly from natural specimens, and William Pegg, whose botanical studies were also painted from nature. Edward Raby's flamboyant style covered the entire surface with decoration, and Kitty Blake painted simple flowers. Most of these artists worked for the established factories of Derby, Worcester, Coalport and Minton. In America Franz A. Bischoff was called the 'King of the Rose Painters' and renowned for fine porcelain work before he became an easel artist. Franz Aulich, George Leykauf, D. Campana and de Longpre are all recognized as master flower painters and their work is still eagerly followed.

One watercolour flower artist who must be mentioned is Catherine Klein, a gifted German lady who painted with great artistic polish and who has been an immense source of inspiration to many ceramic artists, with her many studies still in use today.

All porcelain painters started at the bottom of the ladder and worked their way up, spending hours developing and perfecting their own style and technique. Flower painting is a very individual art, with some artists preferring to portray a single bloom, using the white porcelain as the background, while others wish to cover the whole article being painted. It must be remembered that we all differ in disposition, and what may appeal to one person may not appeal to another.

Flowers are the principal forms of decoration on porcelain, and once the student has completed the technical formalities the choice of style should be his or her own. In time and with practice, everything will fall into place and favourite techniques will become apparent according to personal ability. Refer to Chapter 1.

CHAPTER 1

BASIC RULES AND METHODS

The purpose of this book is to start you painting on porcelain and to show you the techniques involved in using mineral oxide pigments, which are the enamel colours required for overglaze painting. Aim to become completely familiar with the colours, and to discover how much or little they alter when fired in the kiln. In this way you will know exactly what you can do with them. Once involved in this fascinating art form, you will find it an absorbing and extremely rewarding pastime. Do not be too ambitious at the beginning. Choose a simple design and get used to the medium. Once you have mastered the basics you can then introduce your own personality and style. We each have different tastes, and it is this very individuality that makes art so interesting. Strive to be unique and different and to bring something fresh to the art form when you move on to your own choice of subject.

So often the beginner is drawn to producing a full-blown pink rose on a plate. While roses are a superb subject to paint, they are extremely difficult to accomplish and the amateur would do better to avoid them at the beginning. Later on, when you know about light and shade and how the delicate colours perform when fired, you can produce your perfect rose. And if these particular flowers are your favourite, I suggest you study the work of Aulich, Bischoff and Campana, whose studies are regularly featured in the American monthly journal *The China Decorator*. More recently, Sonia Ames and Wanda Clapham, from the USA, have specialized in the painting of roses and have published books on the subject.

It is far better to practise your brush strokes and padding on a plate, afterwards wiping it clean and starting all over again. Keep doing this until you are really happy with the way you are handling the paint, brush and pad. You may find that holding a piece of porcelain to paint is tricky, and it takes time to get used to working on the shiny smooth surface. Unlike a canvas or textured paper it is quite toothless, and there is nothing for your paint to grip. So patience, practice and perseverance are essential. Remembering these three 'P's will pay dividends in the long run.

The main thing is to keep your applications of paint thin, and without any noticeable build-up of paint. Sometimes newcomers are over-eager to see a finished product and a piece of bad work is fired. The end result is disappointing and discouraging, and everyone is unhappy.

If you are with a teacher, be guided, but if you are working alone be honest with yourself. Your work has to be clean and free of dust at all times, and your colours fresh. And when it is fired you should be able to run your fingers over the paint and feel a smooth surface. Highlights are left white on the porcelain, rather as the purists work in watercolour, leaving the white of the paper showing through where necessary.

This, then, is your goal: thin washes of paint and a simple design. In the following pages you will find some outlines that are expressly drawn for this purpose. I suggest you start with a twelve-colour kit and gradually work on your collection as you become familiar with the tones. If you wish, you can paint a very effective design in monochrome. The Dutch are famous for their blue and white, and it is extremely good practice to execute a piece of work in this fashion as it will teach you shading, and tone on tone.

A kiln of your own is ideal, and if you intend to become serious about ceramic art it is necessary. If you do not wish, or find it difficult, to purchase a kiln at the outset, then it is essential that you at least have access to one, and this is quite acceptable. Owning a kiln of course enables you to fire your work and experiment on your own and your intimate colour knowledge will increase rapidly. To become proficient at anything you have to have the tools.

Material for beginners

If possible, a craft shop that keeps supplies for porcelain painting is by far the best place to start. Here you will find good-quality porcelain, the right types of brushes, mineral oxide paint and the necessary mixing mediums. The following list is basic and all that you will need to start you off.

- Four 6-inch good-quality white glazed tiles. These are for mixing your paint on and working from. Later on, you can buy a boxed palette. This contains a sand-blasted piece of glass, with an air-tight lid, to hold your mixed paint, and can be very useful if you are painting every day.
- A selection of brushes of varying sizes. You must have separate brushes for iron red colours. If they are mixed with other paints they will discolour them. Brushes are your most important tool, so be very selective when buying them, and to make sure that the hair does not divide, ask the shop assistant for a glass of water and rinse the brush well. Draw it out and shake it back to its original shape. This is a very good test for quality. You must have good fine points to your brushes. Shaders are quite different: they need to be thick and bouncy.
- Two palette knives of stainless steel. When buying, always test for flexibility by working them on the counter. You do not want a stiff palette knife that you cannot bend.
- Two chinagraph pencils and one soft lead pencil.
- Two ballpoint pens, one with an ink cartridge and one without. An old used pen will serve the purpose if you remove the spent cartridge.
- A sheet of tracing paper and a small roll of sticky tape.
- Fine sandpaper.
- One packet of cotton-wool balls.
- Several pieces of very fine Japanese silk, cut to ladies' handkerchief sizes and washed and ironed. This is going to be used for padding, so must not have any grain marks running through it.

- One bottle of medium for mixing your paint. This is not the time for you to start making your own medium. Fat oil is often used, but this is very thick and difficult for a beginner to handle. If you are working with a teacher, take their expert advice on your medium. As you become more experienced, you will find the one that works best for you. There is no doubt about it, each artist has his or her own preference. Perhaps later on you can make up your own mixture, according to the type of work you are doing. Some painting requires a slow-drying medium (one which has more oil of cloves added), while other styles call for the reverse. At this stage you would be wise to stay with a mixing medium that is tried and tested. Keep everything as simple as possible.

- A bottle of pure turpentine. Do not use ordinary turpentine, as this is not suitable.

- A bottle of methylated spirits for cleaning porcelain. This is a substitute for alcohol, which is far too expensive.

- A cotton smock to wear, since at all times you must keep dust and fluff away from your work.

- Lint-free rags for cleaning.

- Liquid bright gold, the best quality possible. A little of this goes a long way, and it is a good and necessary introduction to gold work.

- Colours. You will notice that colours vary greatly in price. This is due to the make-up of the pigment used in the mineral oxide paint. Naturally the most expensive are those based on gold, such as violet of gold, which when fired has a deep rich colour of velvet-black pansies, and purple, that magnificent colour between red and blue which often appears in nature, and glows regally when taken from the kiln on its final firing. The firing brings out the minerals contained in the colour. The certain amount of calcined lead which they all contain produces the strong gloss, making them glow and shine and stay put. Before being fired they are not permanent, and can be easily scratched or wiped off. The temperature of the kiln necessary to fuse the colours ranges from 750 to 800°C. Colours do vary, some needing a greater heat than others,

particularly reds. This is where owning a kiln is a great advantage, since you can adjust the temperature to the piece you are firing without it having to be included in a general fire in a shared kiln. The colours needed for the first design I have drawn and illustrated are the following: lemon yellow, deep yellow, olive green, apple green, light red, royal blue, light blue, turquoise, good pink, orange, rich brown, black. These are all strong colours and will also be needed for the second illustrated design. So often, porcelain painters start with a very pale pastel palette, and because of their inexperience the work looks quite insipid and a little old-fashioned, reminiscent of a past era. That is not to say you cannot have pastel work, with shades of eau de nil and rose du Barry, but remember that the white body of the porcelain will show through after firing, so you need strength. It is a good idea to use bold colours in the beginning, and in this way you can see how they fire in the kiln. Nature is full of strong colours and you have to learn how to use them, especially if you intend to paint vibrant birds and bright flowers. You can use your first plate as a test piece, so don't expect it to be your masterwork.

- Six plates of various sizes to decorate. Good pieces of English, German or Japanese porcelain are preferable. But make sure that they are flawless. Look closely for any blemishes, black spots, etc., as these will be drawn out during the firing process and can be spotted immediately when the plate is taken from the kiln.

Preparing the porcelain and drawing design

You now have all the necessary materials to begin. Your workplace must be clean, light and comfortable. Clean your plate thoroughly with methylated spirits to remove any dust and fingermarks. Then give it a quick wipe over with a clean turpentine cloth. Allow to dry.

Your first task is to transfer the suggested design on to your plate. If you can do this freehand, and that is the way you want to start, take up the chinagraph pencil and sketch the outlines on to the porcelain.

Otherwise, copy your design by tracing. Cut your tracing paper to size and trace over the outlines in ballpoint pen; remember to write the word 'UP' on the face of the tracing. When it is completed, turn the paper over and draw on the lines with the chinagraph pencil. Then attach the sketch to the porcelain with sticky tape, with 'UP' facing you and the chinagraph outline downwards on the plate, and go over the lines with your empty ballpoint pen. Gently remove the paper and you will have your outline ready to follow.

I am greatly in favour of originality in designs, but if this is the deciding factor as to whether you take up porcelain painting or not, the use of designs that are specifically made for this purpose is quite in order, and preferable to a poor beginner's drawing. It is really no different from people using knitting patterns which they follow to the letter. Some people are artistically gifted, while others long to be. It is the latter group that I wish to encourage. What is nicer than your own hand-painted dinner set adorning the dresser, even if it is only a gold or silver trim with your personalized initials, or a simple single flower? Working with any sort of paint is a delight and rather like opening Pandora's box, as one art form leads to another, widening your horizons and encouraging you to visit galleries and museums to see the work of artists and master craftsmen. The main thing is to get started. One of my most enthusiastic pupils was 75 years old when she took up the art, and her only wish was that she had commenced sooner. Her constant enthusiasm was a pleasure to work with. Perhaps too much emphasis is placed on what you cannot automatically achieve, and more should be given to what you can do if you set your mind to it.

The next step is to prepare your paint. With the tip of the palette knife, take out a quantity of the required powder and place it on one of the tiles reserved for this purpose. You will have to be careful in getting the paint from the phial, especially if they are small bottles and the palette knife cannot fit into the opening; in this case it is best to gently shake it out.

From my own experience and to overcome this constant problem of getting the right amount of paint from the container, I suggest that you visit the local chemist and purchase some wide-necked phials, and transfer your paint into these as you go along. Make sure you label them and include

any instructions from the original phial. It is far better to do this than scatter your work area with loose powder paint which could spoil your efforts.

Grind your colour with just enough of your medium to make the mixture the consistency of toothpaste, so that it is able to stand up in a neat little pile. Remember that some colours will take more grinding than others – you will gradually get the feel of this, but in the main all pinks and purples are more prone to be grainy. Transfer the prepared colour to a clean tile ready for use, and always clean your work

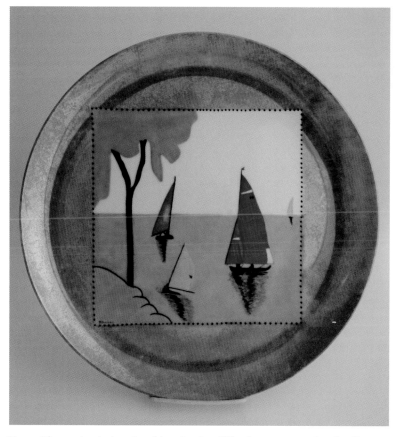

Happy Plate series designed and hand-painted blue lustre surround and sailing boats.

tile with your lint-free rag before mixing the next colour. Continue this procedure until you have all necessary colours mixed for your design.

Have a dish ready with pure turpentine for cleaning brushes, etc. I find a small saucer very useful for this purpose. So often students push down on the ferrule of the brush when cleaning it; far better to roll it to remove all paint. And it is easier to lay your palette knife across the area and take up a smear of turps on the blade if required, rather than dip into a deep container.

Place a small amount of mixing medium on a clean tile. This is to be used for conditioning brushes and to thin the colours when they get too thick.

Pick up your No. 5 brush and lay it gently in the turps, rolling it carefully.

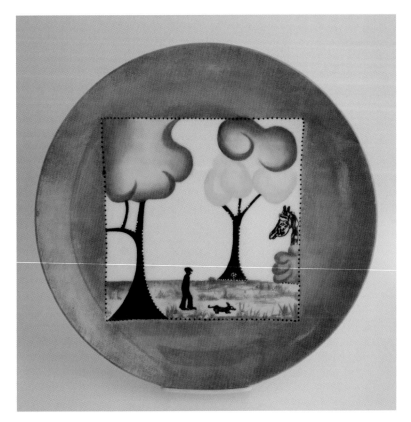

Happy Plate series designed and hand-painted green lustre surround with black enamel dots and man walking his dog with giraffe.

Draw it out over the saucer, removing most of the turpentine, and then squeeze any excess turps on to a clean white rag.

Now carefully place your brush on to the medium and drag towards your body. Use a light touch and a wiggly movement, fanning out the hair of the brush as you press down. All new brushes work better if they are conditioned in this fashion.

Filling your brush

If you have never painted before, it is a good idea to practise some brush strokes first. Use yellow or green, as these are inexpensive colours. Feel the flow of the paint on the clean tile before you start on your plate: it will help you to gauge the texture of the paint. Don't worry about anything other than the pressure and amount of paint that you use. Carefully dip the brush into the paint, taking up a small amount of the colour. Try to apply it evenly and lift your brush neatly. Remember that thin applications are required at all times.

Wipe off and start again. Do this until you feel happy with your technique of application. You want to be able to apply smoothly and stop the paint flow easily, without making blobs and thick areas. At this stage you are learning how to handle the paint on a smooth shiny surface, not how to make specific strokes.

Now that you feel more confident, take up your plate with the prepared outline and carefully follow the coloured design. Always start from the middle of a blank area and work outwards to the outline. Fill in each colour by placing your paint strokes one alongside the other, edge to edge. If you have been heavy-handed and you can see that it is laid on too thickly, pick up your piece of silk, place it over the pad of your middle finger and very gently pad off any surplus paint. Use a clean part of the silk each time you do this. Be very careful not to push down heavily and disturb the paint. Working like this will give you a heightened sense of touch, which is essential in this art form.

You may feel that this design is too simple, but it will give you the opportunity to see how the paint is applied and how to pad off any surplus. And when it is fired you can study the results to see if there has been any alteration in the colour. Make your notes as you go along and you will soon build up a bank of knowledge. If you learn how to apply paint correctly in the beginning, and know what changes to expect from the colours, when you come to painting on an expensive piece of porcelain you will know exactly how many firings to expect from each specific colour. And this in turn will help you decide your decoration.

This is controlled painting and not necessarily the style of work that you will end up doing. Later on, you will be able to paint in a more liberated manner. But it will be ideal for you to start in this fashion and learn the complexities of handling the colours.

When you have completed filling in the design, make sure there are no paint marks on the back of the plate. Study the look of the work, and if you can see any uneven patches make a small pad with your cotton wool and silk and gently go over the area. If you are not happy with what you see, wipe it off and start again. Once the piece is fired it is too late to make amends.

Your plate is now ready for a first firing. If you are having it fired for you, carefully wrap it in clear-wrap so that no dust can get on to it. If you have your own kiln, place it on a shelf in readiness for firing. Do not fire your kiln until you have a sufficient amount of work prepared.

CHAPTER 2

LOADING AND FIRING

Requirements: kiln, refractory batts, tubular props, still. Many different sizes of kiln are available, but most amateur porcelain painters are well served with a standard 13-inch square electric kiln with pyrometer. The internal size of this kiln will ultimately enable you to fire 12-inch vases of varying shapes. Together with the kiln, a certain amount of furniture has to be obtained. Shelves, which are known as batts, and tubular props to stand them on will be required. You will also need stilts to place your painted plates or tiles directly on to. On no account must you ever stack pieces of glazed porcelain on top of each other, as they will stick together. At this stage I suggest you do not buy complicated furniture. Keep it simple and just buy sufficient to start you off.

Personally I think it is wise to use four base supports for the batts, placing one tubular prop under each corner to give an even balance of weight. There is then less likelihood of batts cracking, with consequent breakages.

Regardless of whether your kiln is new or second-hand, it is necessary to do an initial test-fire to dry the bricks thoroughly. Because the kiln will be empty it will reach the firing heat of 760°C relatively quickly. Each kiln is different, and it is difficult to give a specific time that it will take to reach the required heat.

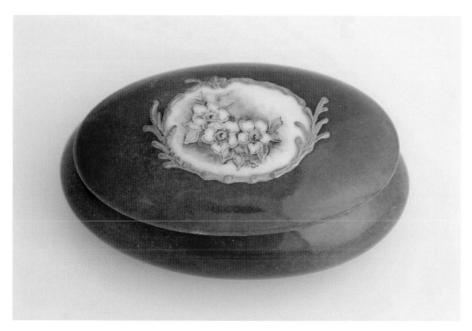

Oval porcelain trinket box with magenta ground, white reserve painted with small open rose and edged with raised paste and gold.

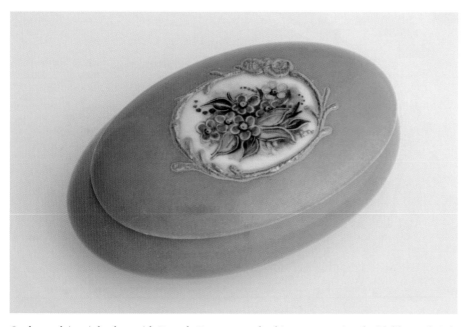

Oval porcelain trinket box with Rose du Barry ground, white reserve painted with blue and pink forget-me-nots and edged with raised paste and gold.

39

Stacking the kiln

For this first firing you will be using plates. Starting at the bottom, place your stilts in position to sit your plate on. Next, corner your four props and place the batt gently over them. Centre the next plate on stilts, and continue in this fashion until you have your work layered ready to fire. Gently close the kiln door. Connect the power and turn it on.

My own tried and tested manner for firing the kiln is as follows. Turn the simmostat control on to 20, at the same time opening the peephole on the front of the kiln to allow fumes to escape. After thirty minutes close the hole and turn the kiln up to 40. Continue turning the simmostat up every half hour until it reaches 100. This is a slow and gradual firing method which I have found very satisfactory. At the same time you will see the needle of the pyrometer moving upwards. When it reaches the required heat of 760°C, turn the power off, turn the simmostat indicator to OFF and remove the plug from the socket. I always try to fire the kiln in the evening, as the power is more uniform. I never open the kiln until the following morning.

This is basically how to fire the kiln. Naturally each firing will be different, according to the contents, so the best thing to do is make notes. As you go along you will learn which colours require special firing. The kiln is rather like your own kitchen oven; each one has its own idiosyncrasies. You soon learn where to place your batch of cakes for the best cooking: too high and they will burn. This is exactly the same with the kiln. There are certain places where the heat is higher, but it all takes time and watchful notation to get the best results.

Slowly, as you go along, you will learn all about your kiln and what it will do for you. Follow good commonsense rules. If you are firing a large special vase, centre it in the kiln so that it has even heat circulation. Don't pack the kiln in a way that anything could tip over and break. And never have anything touching. Your first firing of any article is most important. It must be high enough for the colour to fuse into the porcelain but not so high that it disappears. The only way to know exactly how each colour is going to react

is through using them. Make lots of notes and refer to them. You will find that most colours have their firing temperature on the phial, so keep this in mind. It is exciting to open the kiln door and review your very own handwork. And remember: porcelain painting always takes more than one firing, but how many more entirely depends on what type of work it is and the colours used. Keep applying the paint in thin layers until you have the end result that you are aiming for. After each firing, run your fingers over the work to feel for any uneven patches. If there is a roughness, gently rub over the work with 00-grade prepared sandpaper before the next application of paint.

There are special firings for lustres, gold and raised paste, and these you will find under their own chapters.

GROUNDING AND MORE ABOUT KILN WORK

Grounding a piece of porcelain simply means covering an area evenly with a pure depth of one block of colour, without leaving certain areas lighter than others and without having spotty or gritty 'spit marks'. Also, the colour must not be too heavy, which would cause it to blister in the firing and peel off the porcelain.

However, it must be remembered that since this is hand work a certain amount of liberty should be allowed to the artist. And here lies its charm, that no two pieces of ground work will be exactly the same. Freedom of execution may not bring uniformity but simply a delightful variation in tone, without changing the desired colour.

Should you wish to paint a border for a matching set of plates, it would be advisable to do the grounding simultaneously. Try to maintain an evenness of oil and paint, and fire them together.

Change the position of the plates in the kiln, rotating them from top to bottom on the second firing so that they all retain a high glaze.

Much has been written about the art of grounding, and it is true to say that it can be a very tricky procedure. But if you follow all the rules and constantly bear in mind the ever-prevailing enemies of porcelain painting – such as dust, loose brush hairs and scratch marks – which will not disappear in the firing of the work but only become more obvious, your work will benefit from the care.

There is no question that vases, plates or small objets d'art such as jewel boxes are immediately enhanced by the addition of a ground colour. With the added embellishment of raised paste and gold or silver, the work will gain an extra artistic dimension.

As in all art, experience is the successful teacher. Be prepared to start with a small plate, and practise on that. Then, when you have really mastered the technique of grounding colour, you can gradually work your way up to other, more intricate shapes.

Don't be too ambitious. Choose a colour that you are familiar with, one that fires well. A good pink, or an apple green. Leave the more expensive and rich colours, such as turquoise blue, violet of gold and cobalt, until such time as you are proficient.

Good research on your part will pay dividends. Make notes as you go along about the firing of each colour; discover which ones ground well for you. If you have a favourite colour, perfect that one. It is important that you build up your confidence, so that you tackle the work vigorously. Most of all, enjoy what you are doing and look forward to good results.

You will need …

- A palette for your colour. A piece of glass backed with white paper will suffice, but make it a reasonable size to work on.
- A palette knife.
- A tinting brush, ½ inch or ¾ inch. Sable.
- A good-sized mop brush. Sable.
- A phial of colour.
- A phial of good grounding oil, preferably thin.
- At least six squares of thin pure silk, say 12 inches by 12 inches, pre-washed and pressed, ready for dabbing.
- A medium roll of cotton wool or lambswool. Or alternatively, a piece of foam sponge.
- Masking liquid – coloured red for easy seeing and peeling off.

43

- A bottle of methylated spirits.
- Clean lint-free rags for hands, etc.
- A container for methylated spirits.
- Large sheets of white paper.
- A very fine nylon stocking and rubber bands.

Method

It is essential when laying a ground colour to have the atmosphere as dust-proof as possible. Preferably do not have any form of artificial heating, as it will dry out the process, making it more difficult for you to handle the work. Never wear clothing that is made of fluffy material. Angora or mohair jumpers are definitely out. And do not have an animal that sheds fur nearby.

First of all spread out a large piece of clean white paper over your working area (butcher's paper is ideal). Have your equipment all ready, and your silk padders made up. Thoroughly clean your china with methylated spirits or alcohol.

Before starting the procedure you will have to grind your colour extremely well, so that there are absolutely no gritty pieces. Tip the colour between some sheets of white paper in little mounds, and press and pull with the handle of the palette knife, until it looks very fine. Contact with metal is inclined to change the colour of the yellow range. Grind up a good amount of powder and save it in a clean jar.

Now that your colour is ready, tip some back into a medium-sized container. Place one thickness of a very fine nylon stocking over the top of the paint container and secure firmly with an elastic band.

Place a small amount of the clear oil on to the tile, and add a tiny pinch of the colour you intend to use. Mix it well together. The atom of colour will help you to see that your oil is evenly applied, and that you have not missed any places. It *must* be even or the colouring will be patchy.

Take up your piece of china, and with your tinting brush generously brush the oil all over the shape. Then cross-hatch over the oil with the brush,

until the work is really tacky and hard to move. Keep working until the oil grabs the brush. Now very carefully pad the oil until all loose oil is lifted from the piece. Set aside for at least five minutes.

When ready, pick up your phial of colour with its fine silk covering, and sprinkle over your piece of china as you would with salt and pepper.

Use plenty of colour. Do not skimp. Cover all over the oil with the powder. The secret of an even grounding is to have a liberal amount of colour between your brush and the oil, and not to push down too hard so as to disturb the oil film.

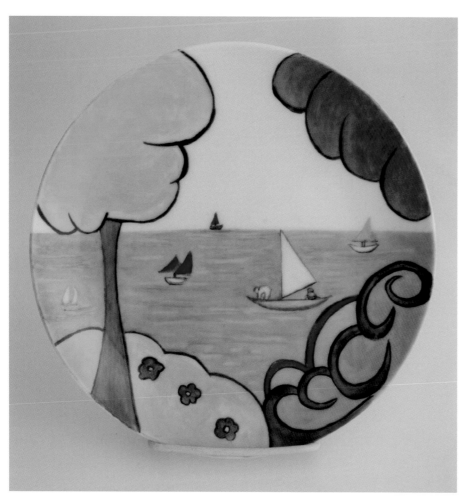

Happy Plate series designed and hand-painted with yellow and blue trees.

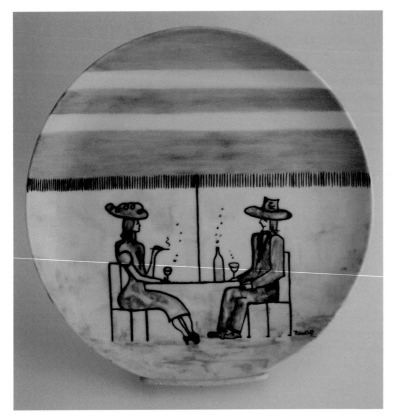

Happy Plate series designed and hand-painted a champagne day under pink umbrella.

With your mop brush, pat very lightly into the oil in circular movements. Use the mop brush by scooping up the paint as you go. Smooth the loose paint in a circular action, and shift the excess to the bottom edge of the plate. Work very, very lightly.

Do not disturb the grounding oil or you will be left with a bare patch. The loose paint can now be removed on to your clean white paper. Gently blow off any obvious patches, but be extremely careful not to mark the piece with moisture (your spittle) during this process.

If the work is masked for a design, now is the time to remove the masking. Carefully lift it up with the tip of a very fine mapping pen, and take hold of the rubbery mixture with your fingertips. It should peel off easily, leaving your design area colour-free. Make sure that you do not drop it back down on the china and disturb the colour.

Now is the time to tidy up. If the edge needs to be cleaned, dampen a cloth with a very little methylated spirits. Hold it over your first finger and rub the edge of the dish. Do not leave a build-up. Cleaning must always be done thoroughly, as any unwanted colour left on the article will be fired in.

Examine the china with a critical eye, holding it at various angles in a good light. If there is an obvious bare patch or a scratch, it will remain that way. Remember always that what you see is what you get. Do not be

disappointed if you have made an error. Simply remove the whole effort and start all over again. This is a much better proposition than firing a piece of porcelain that you cannot end up showing. A second coat of colour will not cover mistakes.

If you are fortunate enough to have a kiln, it is advantageous to place the article directly on the shelf in preparation for firing. Otherwise keep it in a dust-free area: a lidded box is useful. Continue working until you have enough ready for the kiln, then fire the kiln at 860°C. (See Chapter 3.)

When the article is taken out of the kiln, a 00-grade piece of sandpaper is used to smooth any minute particles of grit. Always have a couple of pieces of sandpaper prepared for your work. This means softening them up by rubbing them together briefly.

The same procedure is then carried out for the addition of a second coat of colour. Use clear grounding oil this time. Fire and repeat until you have the true colour. But remember, if you are using a light colour you will have a light grounding. It is the accumulation of colour that makes it deeper in tone.

You should now have a piece of porcelain ready for your next addition of decoration.

CHAPTER 4

LUSTRES AND FIRING

The history and fascination of this beautiful iridescent metallic mixture has been well documented, with the use of lustre being first developed to adorn earthenware pottery in Mesopotamia during the ninth and tenth centuries.

It was brought to Spain by the Moorish invaders in the Middle Ages, where it was perfected and used predominantly on the Hispano-Moresque tin-glazed wares. Later still, it was greatly favoured to enhance Renaissance Italian majolica.

Art has its fashions in common with all other aspects of life and lustre ware faded from favour over the years, before experiencing a huge revival in the nineteenth century. Commercial liquid lustres were developed, and became readily available to all ceramic artists and studio potters, stimulating a renewed interest in the medium and its technique. It is these metallic lustres which we use today, based on gold, copper, platinum and silver oxides.

At the same time a lot of experimenting was taking place because of these commercial mixtures. Exciting discoveries were being made by the Arts and Crafts movement in Britain.

Distinguished potters like William de Morgan (at his studio in Chelsea) were rediscovering old processes and developing new colours, including ruby red. And the now famous and much sought-after 'Fairyland Lustre' was designed and produced at Wedgwood under the magic hands of 'Daisy'

Makeig-Jones, whose flamboyant imagination and skill with lustred powder-colour grounds and gilt-printed outlines established her, along with Wedgwood, as leaders in the field of lustre decoration.

Many examples of this exotic work can be seen in the Wedgwood museum, where a large collection of lustre ware is housed. Early experimental pieces with 'Moonlight-Lustre', a splashed technique, and 'Ordinary Lustre' with various designs on vases, working up to the famous plaque of 'Elves in a Pine Tree Pattern' and 'Imps on a Bridge and Tree House' combined the use of lustre and gold work to perfection.

Lustre colours when fired are brilliant, and extremely beautiful if used prudently. They can be seen to great effect in combination, using the technique of applying successive coats of different coloured lustres to obtain rich glowing iridescent effects. A peacock green can be produced by a light green over copper lustre. An orange lustre fired over rose will give you a shell effect. But each lustre has to be fired before adding the next. If you wish, you can leave some of the next colour showing, and add your next irregularly, or in some pattern to give the piece even more interest. The combinations are endless, and it is interesting to experiment. But equally they can be used straight from the bottle to produce their own individual colours.

Mother-of-pearl is perhaps the most popular lustre and can be used very successfully and with great ease. It is not so thick in texture as other lustres and consequently is less likely to blister in the kiln. But it should be used judiciously, and not made to cover a large surface of porcelain, otherwise it will streak and look blotchy. This delicate lustre when fired should look exactly as the name implies, and bring to mind the iridescent pearly white of a natural abalone sea shell. There should be no hint of yellow to mar the desired pearly-whiteness.

Lustres should be used in small areas, lightly and airily, and in the same fashion as Mother Nature does herself. We have all at some time marvelled at the iridescent colours of dragonflies, butterflies, beetles, hummingbirds, peacocks, fairies. These all have a touch of lustre on their showy wings, but

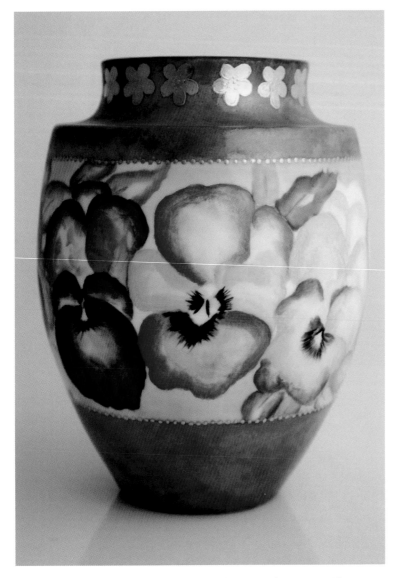

Above and opposite: Matching pair of Furstenburg porcelain vases, with reserves of green lustre, embossed with floral enamel paste and gold work, together with a circle of hand-painted pansies edged with gold enamel dots. Design worked from artist's original watercolour.

not too much to offend our taste. Occasionally the lustre exhibited by these creatures is bright and vibrant, catching your eye and firing your imagination, while at other times it is pale and shimmering, glowing with iridescence like mother-of-pearl. So, with the addition of an outline of bright gold or silver, they would all make exquisite subjects for the technique of lustre.

It is not advisable to use lustre for tableware. This radiant substance is not a suitable candidate for the washing-up machine, nor should it come into contact with any acid which may be in a salad dressing or the like. It is a richly decorative material and will lose its brilliance or completely wear off if used for a mundane purpose. Lustre is a centrepiece, proud as a peacock displaying its splendid plumage. Use it for a cabinet piece, a special vase, or to adorn a hanging plate or plaque.

Lustre fires well on any type of porcelain, but the firing varies according

to the hardness of the porcelain. A lighter firing is necessary for a softer glaze porcelain such as Belleek, which lends itself to lustre very well because of its translucent qualities.

Light-coloured lustres need a medium fire; purples, gold and ruby require a gold fire, yellows, greens and dark blue a hard fire. If disaster strikes after firing a coloured lustre, a thin covering of mother-of-pearl can rectify most mistakes and help to 'fix' the colour. This mother-of-pearl lustre is an invaluable aid.

Lustres are basically all the same colour before they are fired, being a dark brown as seen in the bottle. They become a slightly lighter brown when painted on the porcelain. Make very sure

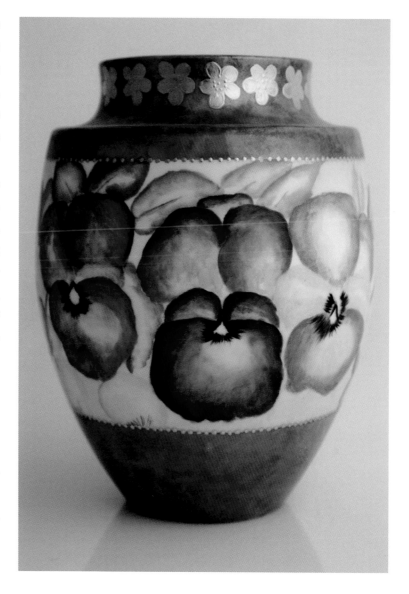

that the colours are well marked, and never mix the lids from one colour to another, or this will create problems when the lustre is fired. And unlike your mineral colours, you cannot paint one lustre over the other without firing between painting.

You will need ...

- A bottle of mother-of-pearl lustre.
- A bottle of light blue lustre.
- A bottle of lustre thinning essence.
- A bottle of methylated spirits.
- Square shaders, No. 6 to No. 8 for general use; about as many as you have lustres.
- Camel's hair tinting brush, for large surfaces.

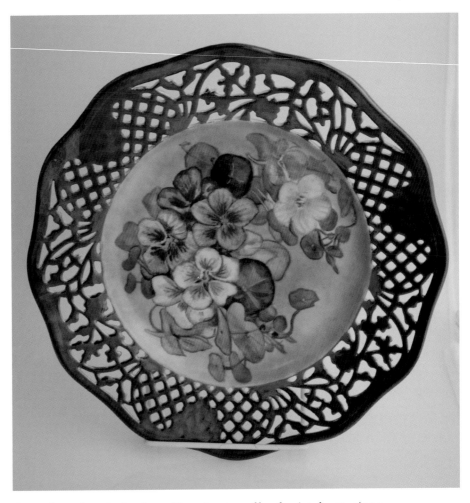

Copper lustre fancy lattice plate, with centre piece of hand-painted nasturtiums.

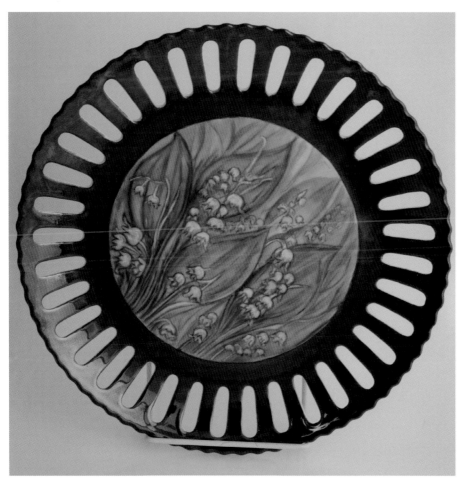

Copper lustre decorative ribbon plate with hand-painted lily-of-the-valley.

Method

Shake or stir the coloured lustre well before use, making sure that it is thoroughly mixed so that there is no sediment in the bottle, unless otherwise specified. (Never shake lustres based on mother-of-pearl or pearl 1, as this breaks up the balance of the mixture, a bit like curds and whey.) This liquid is much thinner and easier to apply. It must be said that lustres are very temperamental and have to be treated like great performers, which they can be if they are handled with tender loving care. They are greatly affected by

53

moisture, and the mixture is more receptive to a warm dry piece of porcelain than to a cold piece.

Once again it must be stressed that cleanliness is most essential in the handling of lustres. The article must be thoroughly cleaned with methylated spirits and allowed to dry. Any finger or pencil marks will show through the fired lustre.

Dip your chosen brush into the bottle of lustre, removing the superfluous liquid as you draw it out. Cover the piece of porcelain as fast as possible, using broad strokes with your brush held flat. Try to blend the strokes together with a criss-cross action. Lustres dry very quickly, so you must be swift with your brush. Although some people pad lustres with a silk-covered ball of cotton wool in much the same manner as you would a piece of grounding work, I do not advise this method. It reduces the depth of colour and necessitates extra coats. However, if you are using two different colours side by side, you will have to blend the edges together with a pad. But do this very gently, trying not to lift the lustre but merely joining the two together.

If you would rather use the lustre from an open dish, prop up one side so that you have a nice 'well' effect. But you cannot return unused lustre to your bottle, so keep this method for covering a large surface. You can add a drop of lustre thinning essence to the lustre if it has gone thick in the dish. Speed is essential, as the everlasting problem of dust in the air can cause havoc with lustre.

Once the piece is painted, try to dry it out by artificial heat. A low temperature in the kitchen oven is ideal, but do not close the oven door as the fumes are strong and need to escape. If you fire a piece that has a coating of dust, the dust burns off in the kiln and leaves irreparable little white blotches.

So the method is: speed. Dry the article artificially, and place in a covered box or similar. And keep your fingers off the lustre before firing. This may all sound rather daunting, but it is quite simple once you get the knack of handling the lustre. And your end results will be well worth the effort.

Most lustres require two thin coats to obtain their full colour. This especially applies to light shades, but quite often you can get a good result with one application of a strong colour. And with practice you will be able to recognize at a glance, as it comes from the kiln, which one needs a further coat.

Firing plays a great part with lustres. If a lustre is underfired it will stay suspended above the porcelain and rub off when touched. If this happens you will have to clean off the entire coat with methylated spirits and start again.

It is a good idea not to crowd the kiln when firing lustre, so that the heat is able to circulate well. Keep the keyhole open until the kiln reaches 200–300°C and all the fumes have been fired away; they are very strong initially but will soon vanish completely. Close the vent and fire at the required heat. Most of the commercial lustres that are available today will have a firing temperature guide with them.

A good idea for a beginner is to use four bread and butter plates. Paint each with a different coloured lustre, including one with mother-of-pearl. Fire and record the results in your note book. Then coat half of each plate with a different colour lustre. Record again in your note book which colour is superimposed on which. Fire again and keep these as your samples. This way you will have eight results to think about, and can then decide which one you would like to proceed with. It is fascinating to see how lustre combinations can work. And the best way to observe this is by your own practice. Read about a suggested combination and carry it out, but also experiment yourself. In this way you will learn more about the use of lustres, and perhaps discover a new exciting combination, one which you can adopt to advantage to your own use.

Here are some well-known combinations:

- Blue green over gold lustre results in a very rich green.
- Light green with a second coat of iridescent green is extremely pretty.
- Ruby lustre over polished burnished gold is very deep in colour and excellent for panels or bands.
- Light green lustre over fired copper lustre makes a beautiful peacock green.

- Fired liquid bright gold covered with mother-of-pearl lustre is superb on small pieces with raised paste.
- Fired liquid bright silver covered with iridescent blue lustre gives an iridescent silvery effect.

The main thing is to keep notes and decide which combination will blend with the rest of your type of work. Lustres can open a whole new style for you, so be prepared to be flexible and fearless.

CHAPTER 5

RAISED PASTE – DESCRIPTION AND MATERIALS

The addition of raised paste as an added decoration to a piece of porcelain is rather like putting the icing on a wedding cake. Imagine your cake mixture: lovely to eat before cooking, with all that beautiful dried fruit and those lush red glazed cherries. Once baked, it becomes a solid piece of food. It may be round or square, and looks interesting but lacking a certain finish, a special flavour. Coated with an icing, it may look sweet but rather bare and somewhat plain. But with the addition of roses, silver dots and scrolls and all that glorious fancy work, *voila!* the cake is unique. It is all the more in keeping with the joyful event, the eating of it is far more satisfying, and the occasion becomes all the more memorable.

Such is the case with raised paste. This intricate relief work can enhance anything that you may wish to decorate, from a small brooch to a lavish pedestal vase. Once you have added all the trimmings to your chosen piece of work, it could well become your masterpiece.

Start with a yellow powder, which is mixed with a medium and then covered with gold or silver. The paste may be applied to soft- or hard-glaze porcelain, over ground colours, fired lustre work or gold, or on plain white.

Sparkling gold or glittering silver adorning an otherwise mediocre piece

of porcelain can shoot you up the ladder of fame. This has been the case for many a ceramic artist who has taken the time to perfect this decorative embellishment. Experiment with your skills, and discover whether this particular fine art work is your forte.

Once again I suggest that you start small and work your way up. Even a simple design on a plain plate is very effective. When you have achieved perfection, do gild the lily well.

This is an opportunity to really go over the top. And why not, since you have taken the time and effort to master the process? A good spread

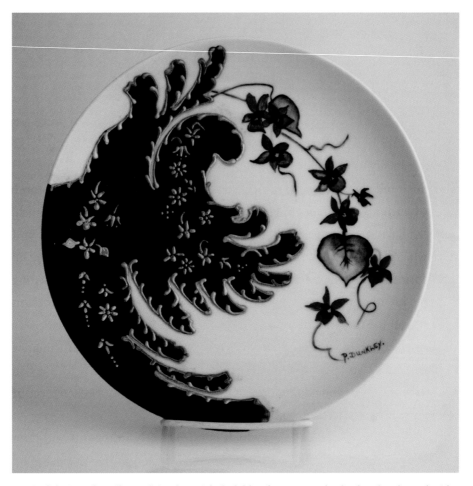

Original design of small porcelain plate with dark blue fancy ground, edged and embossed with raised paste and gold work, together with a flow of hand-painted violets.

of raised paste in a fabulous design can look simply stunning. It really is the icing on the cake, but unlike the icing it can be kept and admired for ever.

If possible, study the works of the Old Masters and you will see how magnificent the addition of raised paste is to the look of the finished article. This is the last adornment that you can make to the piece of porcelain, as raised paste will not tolerate more than three firings. Have your painted design completed before starting, and the ground colour laid, unless of course you are working on plain white.

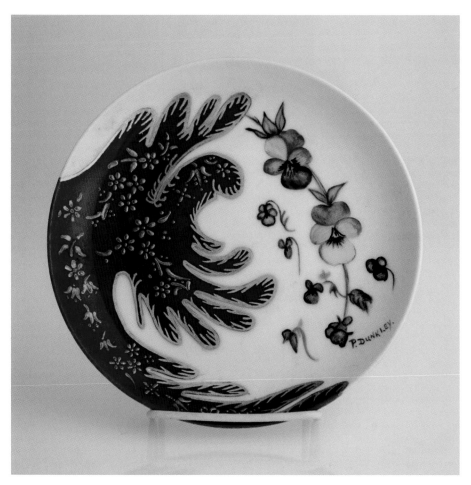

Original design of small porcelain plate with swirl of maroon ground, edged and embossed with raised paste and gold work, together with a scatter of hand-painted pansies.

You will need ...

- A phial of Hancock's raised paste.
- A phial of paste medium.
- A sable brush no. 0 or 00.
- Pure spirits of turpentine.
- A small dish for turpentine.
- Lavender oil, to wash all brushes used for gold.
- A pat of unfluxed gold.
- A new palette knife.
- A needle or mapping pen.
- A piece of glass or tile to use as a palette.
- Methylated spirits.
- A pair of white cotton gloves and a glass brush or burnishing sand.

I suggest that all these are kept strictly for raised paste.

Method

First sketch the design on the porcelain. You can use a Stabilo pencil, graphite or Indian ink. If you are working over a dark colour, use a white pencil.

Once you have your design in place, apply the paste confidently and evenly, as broken strokes are not satisfactory and cannot be repaired. The flow has to be maintained.

It is a good idea to grind your powder first of all to make absolutely sure that there are no lumps. This procedure can be helped by adding a few drops of turpentine during the grinding, as it will evaporate and dry back to the powder form as you work the paste.

Place about one teaspoon of powder on to the tile, and carefully add a drop or two of the medium (fat oil) and mix hard so that the powder is cut, not in a circular motion but forward. Mix it to a biscuit-crumb consistency, just sufficient for the powder to bind together. It should look rather dull and dry.

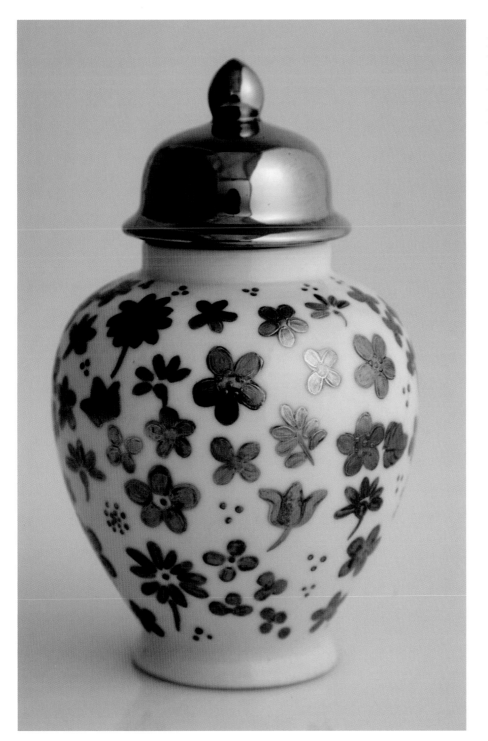

Silver lidded white porcelain ginger jar, with freehand all-over raised paste design then hand-gilded with best silver and fired.

Silver lidded white porcelain ginger jar, with patterned raised paste design, then hand-gilded with best silver and fired.

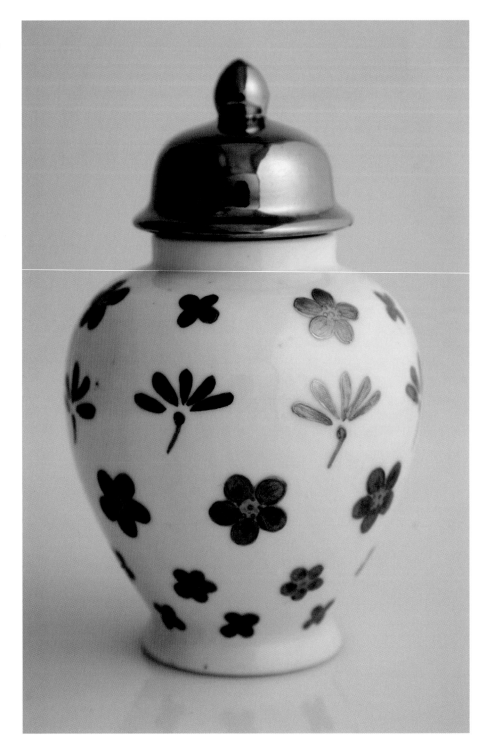

Add a little clean, pure turps with the blade of the palette knife. Try to keep the paste in a neat compact pile while you grind it well into a stringy consistency. You should be able to pull your brush through the mass and deposit the paste in an even line without really touching the china. If you are using dots, the paste must be stiffer.

When your brush becomes clogged with the paste – and this happens regularly – dip it into the turpentine dish, roll it around on the palette and wipe it on a cloth kept for this purpose.

The paste mixture has a tendency to dry rapidly, so you will have to add a drop of pure turpentine to keep it nice and stringy: also huff on the mixture a little and turn it over with your knife. If it becomes too oily it will flatten out when applied to the porcelain. You will then have to add a little fresh powder paste, and breathe gently on it as before.

Once again practice makes perfect. It is a good idea to just keep doing scrolls, lines and dots on a piece of blank porcelain until you can handle the mixture confidently.

Hold the brush so that it is perpendicular and only the point of the paste touches the porcelain. When you feel more comfortable, move on to the article you intend to decorate.

As you become more experienced and you wish to model in high relief, the first coat may be applied, left until almost dry, then more added. The trick is not to let it get too dry or it may separate in the kiln. A larger brush may be used to help you float the paste over bigger designs. Remember, though, that the paste has to be covered with gold or silver.

Never, never place raised paste in artificial heat to dry. It must be completely air dried or it is likely to chip off. It may take two or three days to dry out completely. Place your piece of work in a dust-free area, but where the air can circulate – a box with some holes in it is a good idea.

It should look completely dull when ready for firing: if it shines, it is too oily, or not dry enough, and may spread in the firing. You will soon recognize a good finish.

Fire at 720–760°C. If it is fired too hard, the paste will glaze and chip off.

It really only needs a moderate firing. When it comes out of the kiln it should look yellow in colour, very like the powder mixture. If it is brown it is underfired.

The next step is to cover the paste completely with unfluxed gold. The raised paste is very porous, and must be thoroughly saturated with gold in order to be rich and bright after firing. Be very careful not to go over the edges of the paste design and mark the china, otherwise you will have to clean

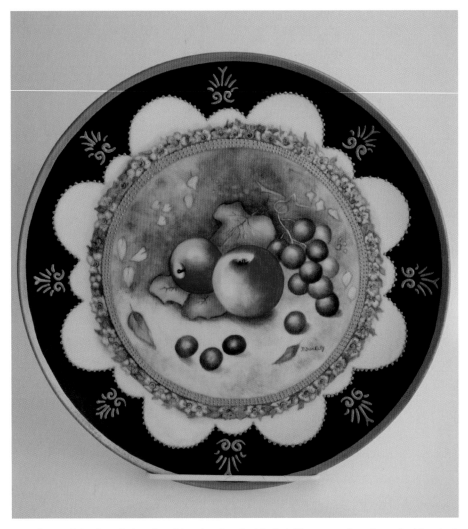

Superb porcelain plate designed and hand-painted with dark blue ground, embossed with raised paste and gold gilded, fruit centrepiece edged with gold and open roses.

around the area as smudged gold fires black and looks dreadful. Use the lavender oil to soften the pat of gold before application. Only ever clean up gold with methylated spirits.

Study the work and make sure you haven't missed any areas. The unfired gold will look like dull brown paint. When gilding a paste line, keep your brush left of the line, turning your dish to go up one side and down the other. Do not try to cover the area in one sweep.

Finally, after firing your work again at 720°C you will have to burnish the gold. Do this while the piece is still warm. Wear white cotton gloves and use a glass brush, very carefully. If you prefer to use burnishing sand, hold the work over a bowl and sand lightly. The more you polish, the brighter the gold shines.

It is a recognized fact that sometimes raised paste chips off our fired porcelain. This is disappointing, especially if the piece has taken a long time to complete. So always make sure that you are familiar with the type of glaze on your porcelain and how it reacts in the kiln. Is it a soft-paste porcelain or alternately a hard-paste? As a general guideline, English bone china is a soft glaze, while German, Japanese and Chinese porcelain is hard. Once you have discovered a good working porcelain, stick with it if possible.

There are some very old and elaborate ornamental pieces in various collections around the world, simply lavished with raised paste and enamel work and still in pristine condition. There is no reason why your work should not stay complete. Follow the rules, make your tests, and keep a note book. You will have good results.

CHAPTER 6

GOLD AND SILVER: FORMS AND APPLICATION

Just the mention of these two desirable materials in connection with porcelain decoration conjures up the thought of expensive and beautiful works of art. And no serious porcelain painter should be without some form of this precious compound, even if it is only liquid bright gold or liquid bright silver, which is also known as platinum. These are an essential part of a beginner's palette. They can be purchased in small amounts and if used with care and consideration will enhance a surprising amount of porcelain.

Gold and silver work is much sought after for anniversary and wedding plates, and as Christening gifts. And what is nicer than to receive or give a special hand-painted piece of porcelain for such an occasion? In fact, you could specialize in gold and silver work alone, making a niche for yourself with your own personalized designs, if that happens to be your favourite medium.

Once you have learnt the intricacies of these precious materials, use them with flair and imagination and not just on the edges of plates and handles of cups. Leave that form of decoration to the porcelain factories, and strive to make your gold and silver handwork unique.

So often we are told that we must not 'overdo it' and are advised to keep the addition of gold and silver to a minimal amount. But why? If you are making a statement with these materials, do it boldly and show them off to

their full advantage. After all, they are expensive and sometimes deserve centre-stage to themselves. We are all different, and what pleases one may not please another. But the important thing is to be true to yourself and your own inclination, and not to what somebody else tells you. If you feel like doing a whole piece in gold and silver and making it very ornate, do so. And in this way we will eliminate the sameness that sometimes appears in this type of work. You will find that there are lots of people who favour gold and silver, and they are happy to pay the extra cost involved to have that exceptional piece. But make sure you always use the best material that is available, if this is to be your principal embellishment.

There are many types of gold and silver on the market and they each have a varying percentage of actual gold or silver content. Liquid bright gold can be purchased from a range with an actual gold content varying from 6 to 12 per cent; naturally, as you would realize, the higher the percentage of gold, the more expensive it is. This also applies to the other golds, such as paste gold and liquid gold, which can be purchased in percentages as high as 75 per cent, and powdered gold which can even be 99.8 per cent. It is easy to recognize the top golds when you see them on a finished piece of porcelain. They look rich and expensive and gleam with the status of their fine quality. Today in the auction houses, exquisitely hand-painted and glorious gilded porcelain astounds the audience with the astronomical prices that are paid. These works of art have high gold content and top carat value, as well as their antiquity, to entice buyers/collectors.

All decorator gold has a certain carat value, just as in jewellery. Discerning people can see at a glance which type of jewellery has the most carat value by its colour. Pure gold, being 24 carats, has a distinct reddish tone. And this is the same with the gold that is used on ceramics. Once the small amount of flux that is used as a facilitator is burnt away in the kiln, the fired bright gold deposit can be properly designated from 22 to 24 carat. The gold content such as is found in burnished gold, especially the reddish gold, ranges between 22 and 24 carat. An easy guide for the beginner is to see a sample of the fired gold before you purchase it, and then you can visualize what you can do with

it in your particular design. Whether it be a mix of bright or yellow gold, burnished gold or silver, ultimately the main criterion lies in the quality of your end product as shown in the design, technique and durability.

So if you decide to specialize in gold or silver, do your homework and establish the exact content of gold or silver when purchasing the product. In this way you will feel confident in the knowledge that you have used the best product that is available for that special piece of porcelain which you have adorned. It may be a pedestal vase or a heart-shaped jewel box, or even a simple plate, but with its gleaming gold or silver that glows with incredible beauty, it is justly going to become one of tomorrow's antiques.

Requirements for bright gold application

You will probably find a choice of liquid bright gold available, each one with a different quality percentage of gold, as previously explained. There is also a bright lemon gold. Study the supplier's chart and make a choice from that, since the method of application is the same throughout the range.

- A phial of bright gold. Use a good general-purpose gold.
- A pointed sable brush no. 1.
- A 1/8" shader.
- A small plate, to keep as an example.
- A small piece of glass to use as a palette.
- A bottle of prepared 'gold essence' which can be used for all of your gold work.
- Some methylated spirits for cleaning porcelain.
- A small lidded jar for essence, to be labelled 'gold work only'.
- A small lidded jar for alcohol, to be labelled 'gold work only'. These jars are to be used for cleaning your gold brushes.

None of this equipment must be used for any purpose other than gold work.

Method of application

The application and firing of liquid bright gold is surprisingly simple. Before being fired, the mixture appears to be a rich brown in colour, and once the phial is opened it is wise to use it straight away and directly from the bottle, as it will evaporate. Get into the habit of replacing the bottle cap as you work. It is a good idea to set the phial in a piece of Plasticine. Build it up in its own little mound, so that it is safe and cannot be easily knocked over. The last thing you want is a trail of liquid bright gold. If you would rather not work direct from the bottle, carefully place some of the gold on to your glass palette with your brush. This is a good idea if you want to do initials or are writing a name. But bear in mind that it does evaporate.

First the ware must be cleaned with methylated spirits and left perfectly dry. The gold is used as supplied and does not need shaking. Take your soft dry brush, which has been conditioned by cleaning it in the gold essence and then fluffing it out in the alcohol, and merely dip the tip straight into the mixture, applying the gold in bands, lines or patterns on to the porcelain. The composition is such that the correct deposit is obtained without undue spreading. But be careful not to apply it too thickly. Use your judgement and watch the flow. If it is applied too heavily the gold will fire with a scummed finish, or may even blister. If applied too thinly it will have a purple tint after firing. A good idea is to have a small unfired sample for reference so that it can be compared with the fired results. Use two porcelain brooch medallions and make a 'before and after' example.

It is important to be very clean and tidy as you work, as any unwanted traces of gold will fire mauve. Clean your brushes in the gold essence after completion of your work, but not in between. And keep your 'gold cleansing jars' separate. In other words, do not add any other medium to the gold: keep it as pure as it comes.

Never use turpentine to clean stains or fingermarks as these will fire purple. Clean with methylated spirits.

Firing the work

In firing, it is essential to have good ventilation, which is best obtained by leaving the kiln door open slightly until the gold has 'smoked off'. This will happen by the time the kiln approaches a dull red heat. Without adequate air, the gold film will fire out the gold, giving an unattractive finish which is not durable. So do not crowd the kiln and keep the firing slow. Liquid bright gold should come from the kiln with a bright and brilliant gold lustre.

The ideal firing temperature in any particular kiln is best determined by experience, but the following temperature ranges will be useful as an initial guide.

- Bone china 680–760°C
- Porcelain 760–820°C

These are top temperatures. They should be approached slowly during the 'smoking off' period. Once you have reached 400°C the firing may be

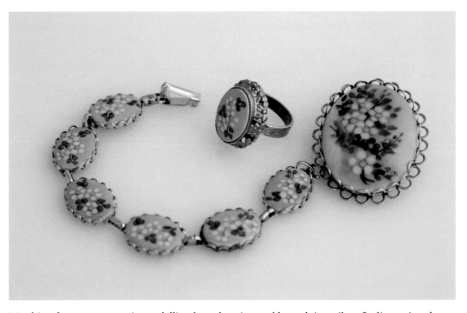

Matching forget-me-nots six-medallion bracelet, ring and brooch in a silver finding painted simultaneously and fired three times.

increased until the top temperature is obtained. Switch the kiln off once the top temperature is reached.

Liquid bright silver or platinum

Application and firing techniques are exactly the same for these precious metals as for liquid bright gold.

Uses for liquid bright gold, silver or platinum

- To decorate white porcelain.
- In designs, banding, initials of names.
- Worked over fired lustres, over etched porcelain.
- Liquid bright gold can be used as an undercoat for both Roman gold and liquid burnishing gold.

Only be satisfied with the best.

In the long run you are best served buying the best liquid bright gold or silver. It will fire more easily and you will only have to apply one coat for good and satisfactory results. If you want to practise working with a cheaper liquid bright gold, that's fine. But once you have found your favourite and best brand of liquid gold or silver, I suggest you stick with it, for you will know how to handle it and what to expect from using your own preference.

Burnished gold

All gold with the exception of liquid bright requires burnishing, as the name implies. This type of gold in liquid form is known as matt gold, and will require a thorough shaking before use. Roman gold comes in small pats, as does unfluxed gold – rather like a cake of eye make-up. The procedure for burnishing (or buffing up) can be carried out with either English burnishing sand, a spun glass brush, a burnishing pad or an agate burnisher. All of this gold when used

correctly will result in a beautiful satin finish. So once again the choice is yours, but this very much depends on what you intend to do with the burnished gold covering. I think the best idea is to explain them one by one.

Matt liquid gold (also known as liquid burnished gold)

This is a very popular gold as it is easy to use once you have shaken it well or stirred it up. It is specially prepared to give a rich, dense film after firing. There are usually at least two varieties with varying gold content to choose from, and this you will easily determine by cost alone. You paint it on in much the same fashion as liquid bright gold, although because it is thicker and heavier to handle it does not flow in the same fashion. But it is not difficult to use and the best idea is to give your article two reasonable coats, firing in between. (Later on, when you become more proficient, you will be able to layer two coats by using artificial heat to dry the first coat before applying the second, and thus have only one firing.) But do not attempt this until you are more experienced in using the gold.

Roman gold

As this gold comes in a block you will have to use a prepared facilitator to thin it so that the application will be smooth. Use your flat sable brush in short cross-hatch strokes, as usually when this gold is used the area to be covered is broad. However, you can use it wherever you like. It is easily controlled, being in a solid form.

Do not mix liquid bright gold as a facilitator. This is a foolish act as it is merely taking away the beautiful satin finish that you can achieve. Always use the correct mediums for the right purpose. After all, they have been especially prepared for that reason.

Roman gold works well on Japanese, German and French China.

Unfluxed gold

This gold is used for softer earthenware glazes such as English bone china, for design work over fired colour, regardless of the type of porcelain beneath it, and for the painting over raised paste work. It has been prepared without any flux.

Firing your work

Burnished gold (liquid matt, Roman or unfluxed) should be fired in exactly the same manner as for liquid bright gold. Do not crowd the kiln and have good ventilation.

Temperature ranges:

- Bone china 680–760°C
- Porcelain 760–820°C

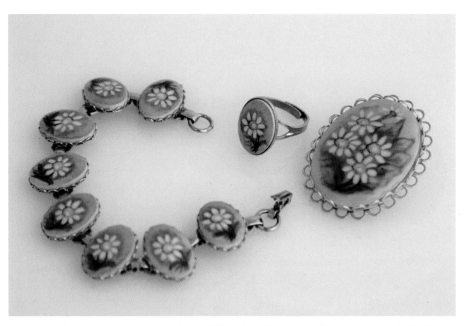

Matching white and green daisies eight-medallion bracelet, ring and brooch, in a gold finding, painted simultaneously and fired three times.

Once again, these temperatures should be approached slowly. If the gold burnishes off after firing it is a sign that the firing temperature is too low or that the wrong burnished gold was used.

To polish the gold

Use white cotton gloves or tissue paper when you remove your gold work from the kiln, as sometimes fingermarks will show after the scouring. Polish it up while it is warm. Remember, you are handling a highly sophisticated form of decoration so treat it with care, just as you would a precious piece of jewellery.

Always contain your burnishing area, preferably away from your painting table. Spread out a clean sheet of white paper, and when you have completed the procedure carefully fold the paper up and discard it straight away. If you are using a glass brush (which is very popular) you would be very well advised to wear rubber gloves under your cotton ones. The tiny glass particles are invisible to the eye but very painful if allowed to enter your skin. A glass burnishing brush is very good for nooks and crannies, which you can quite often have on an intricate vase. All of these things must be taken into consideration when you are choosing your shape and deciding on your gilding.

For large surfaces a small circular motion is best; for bands or straight work just follow the lines. Hold the brush vertically and buff reasonably well. But do not scrub at it – remember it is precious gold. A glass brush is wound with a type of white string which has to be untied as the brush wears down. For extra support wrap the brush in tissue paper as you use it.

You must be very sure to remove all particles of glass from your piece of gold work, especially if it is to have a further firing, as the tiny specks will ruin your work. Wash the piece in running water under the tap.

Burnishing sand is used in much the same way as you would silver polish. Pour some of the sand on to a plate or saucer, moisten the sand with plain water, dip into this with a soft white cloth and gently buff the gold work; some people like to work in a large open bowl so that everything is contained within

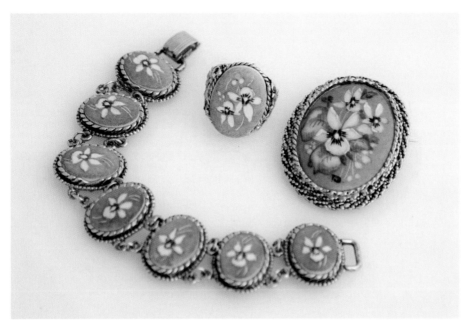

Matching violets seven-medallion bracelet, ring and brooch in heavy bronze finding, painted simultaneously and fired three times.

and they can re-use the sand. A burnishing pad, or agate burnisher, is used in a similar way. It really does depend on what type of article you are polishing as to which method you use, since each is satisfactory.

Gold and silver work is not difficult to do, but there are certain specific rules that you must follow, mainly in the stirring and application of the mixture, and cleanliness. It is not as difficult as the coloured work. Although it might appear complicated it really is quite straightforward. And the results can be positively stunning. In the following pages you will find some designs and possible ideas for gold and silver decoration.

CHAPTER 7

GENERAL OVERVIEW OF SUBJECTS TO PAINT AND DESIGN

Expand your porcelain art to include creating your own unique and individual designs. Whether it is bees or butterflies, squares and rounds, floral and fancy, let your personal motif be your distinctly recognized style of pattern or particular theme of painting, with the rich or pastel colours that you specifically favour. It is very pleasing to know there will be no other design quite like yours in the universe. Do not be satisfied with the ordinary: strive to become extraordinary, and make your mark and give it the 'Wow' factor.

Such is the case for the renowned French Impressionist artist Henri Matisse, whose paintings are immediately appreciated by the inclusion of a design or pattern taken from a swatch of fabric, carpet or some other decorative source. Matisse was inspired by Oriental and Medieval patterns from Islamic art and illuminated manuscripts. He would search Parisian junk shops for scraps of tapestry, silks, embroidery, tiles, enamelled glass, mosaics and ceramics. All purely geometrical items triggered his imagination. His obsession with design began in his childhood, and remained with him all his life, culminating in his scissors work of bold-coloured cut-and-painted paper designs, simplistic line drawings, book illustrations and the publication of

his own book, *Jazz*. With incredible foresight, he decided in his youth that pattern work would become his signature to success, and it did!

Yves Saint Laurent, Zandra Rhodes and a classic following of admirers quickly saw the advantage of using his bright and beautiful cut-out colour and form, and followed suit. His fame and fortune was secured with his distinctive patterns and motifs, which are still in use today by fashion designers around the world.

Without the addition of decorative textiles within his composition, his paintings might have lacked that extra strength and vitality which has made him so appealing to his vast audience. Matisse was never apart from his intriguing fabrics, his favourite being *toile de Jouy*, a blue and white material in arabesque style with fanciful intertwining leaves and baskets of flowers. It first appeared in 1904 and continued throughout his career. The pattern became stronger and more recognizable with the passage of years, indicating his infatuation for design and the need to always include some form, if only a continuation of dots. For him art and decoration were one and the same. When you consider that Matisse did not actually design the fabrics that made his work so famous, but used them merely as backdrops, the outcome is quite amazing.

Within the field of ceramics is another artist whose design work brought her fame and fortune. Clarice Cliff was a vivacious lady with flair whose bright quirky patterns, known as Bizarre ware, epitomized the Jazz era and Art Deco period. This is underglaze work on pottery, and a different technique to porcelain, which is overglaze painting. Her earliest motifs were simple, merely geometrical patterns filled with bright colour, her flowers stylized and recognized by their form. As she advanced her designs, the shapes became far more intricate, and difficult to execute. Square teapots, conical shakers, cups with flat handles, oddly formed jugs – the pottery certainly was unique in design. She continued to produce hundreds of outrageous patterns, naming them after each letter in the alphabet. Blowsy roses, exotic birds, black lilies, purple mountains, comical fish, round, square and oblong flowers – there seemed to be no end to her creativity. She was known as a genius in the world of pottery.

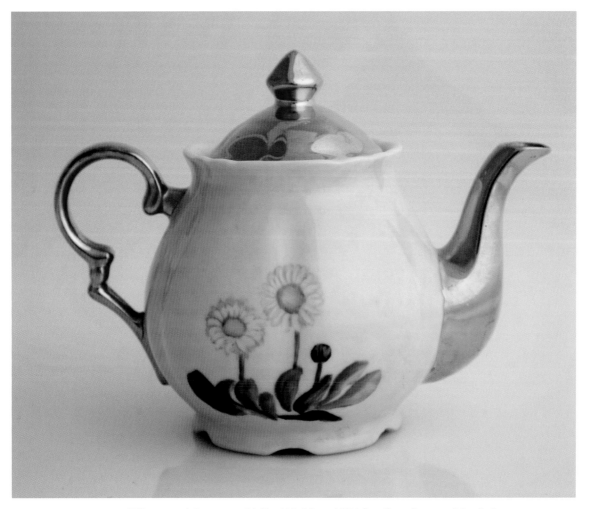

Yellow porcelain teapot with liquid bright gold lid, handle and spout, daisy design.

Her weird and wonderful style was so popular that all the top department stores in London were prime outlets for its sale, and regular exhibitions and demonstrations were held. Design always played a major part in the end product. Clarice Cliff ultimately became the art director and owner of a pottery business in Staffordshire. Today her pieces are highly sought after and fetch astronomical prices. This remarkable ceramist has a huge following and collectors clubs around the world.

We are all influenced by different craftsmanship, consciously or

otherwise, and the mix can be beneficial. Do not hesitate to purchase fellow artists' work: it is necessary to have variety surrounding you to stimulate and inspire the creative mind. Who knows, it could be a future masterpiece.

The design patterns for pottery and porcelain have a history dating back to the thirteenth century and have been twirling ever since. Designs from Mesopotamia (Iraq), Africa, Turkey, Spain, Italy and Persia, together with the Hispano-Moresque style, a combination of Islamic and European motifs, have long been favoured and still are. Tiled panels of colourful birds and flowers, lustre ware and majolica, are all enjoying a revival in the Arts and Crafts. Much loved Classical Greek and Roman designs with intricate ornamental patterns are still adapted for borders on plaques.

At the beginning of the sixteenth century, Bernard Palissy developed his own named ware, decorated with realistic plants and animals. At the end of the century the Dutch produced Delft, much in the style of majolica, earthenware with coloured ornamentation on opaque white enamel. In the seventeenth century Thomas Fitzhugh, director of the British East India Company, ordered a dinner service in the pattern which bears his name. It represents the seasons, embellished with clusters of flowers and symbols, with a central motif. This proved extremely popular and was still in production at the end of the eighteenth century.

At this time it was fashionable for wealthy Europeans to order dinner or tea and coffee services to be made in a province of China. They would include a sketch or watercolour, a bookplate depicting their coat of arms, and their choice of border design. Pattern books were essential and still are an integral part of all ceramic factories, recording pattern numbers, dates and description of the piece, size, colour, glaze and general discussion as to its popularity. They tell us when a particular pattern was first introduced, when it was discontinued, or whether it is still in production. These books are historical gems and a gold mine of information for the companies concerned.

In the 1800s certain continental ceramic manufacturers specialized in drawing original designs for porcelain in pen, ink and watercolour. These

were intended as reference sources from which the painters could work, using the patterns and colours chosen. The image would be transformed from paper on to fine porcelain. Many of the designs were reproductions from museums and private collections, copied under licence.

From the Qing dynasty came exquisite fine work depicting Chinese *famille rose*, a blanket term used for categorizing a piece by its colour, with blossoming lush peonies in delicate rainbow shades of pink, *famille verte* (tints of green) and *famille jaune* (yellow). The artistic world of porcelain was besotted with Chinese patterns, forms and colours, and export continued well into the twentieth century.

Inter-copying in major factories was a common practice, particularly in France and Germany. Patterns were reproduced from Meissen, Sèvres, Chelsea, Coalport and Derby, to name only a few. Each company would put out its own version of a certain design to suit its clientele. Spode, Derby, Worcester and Doulton all produced superb Japanese Imari-style ware depicting blossom, birds and stylized flowers, with the chrysanthemum being dominantly featured.

The 1900s saw the introduction of commemorative plates and a firm order from a Fifth Avenue, New York, store requesting a commemorative Christmas plate. Spode was approached and the pattern books were used to search for antique designs and motifs to fit the request. A designer was chosen and a 10-inch plate with a Christmas tree pattern was developed. This proved popular, and it was not long before other companies produced similar designs.

Now, in the twenty-first century, much has changed in the world of ceramics, but nothing can take the place of a memorable lasting design. The Onion pattern – which has nothing to do with onions – is a grouping of floral motifs of peonies and asters flowing around a bamboo stalk, plus Japanese peaches and pomegranates symbolizing fertility and abundant healthy children. It originated in Czechoslovakia and has been in production for three centuries. The longevity of a design is difficult to assess, but once established can last for ever.

The creative possibilities are endless. Weddings, birthdays, anniversaries, signs of the Zodiac, floral work, birds and animals … special occasion plates are all extremely popular. Make a resource file – cards, photos, pressed flowers from the garden, ideas and inspirations to kick-start you into the magic world of design.

By necessity our canvas is limited, but as we have seen this does not prohibit flair, and riotous patterns can be created and ultimately adorn our beautiful porcelain, which is as popular today as it has ever been.

Watercolour painting

I suggest you first paint your designs in watercolour, as was featured in the past. Become familiar with this medium in an intimate way by working small. Build your book of patterns so that you have a reference source that is unique. This medium is twinned to porcelain painting because they both work from light to dark, and require layers of colour to build up their depth. Traditionally, white is maintained by leaving the paper blank where needed, and this can work well in design. Consequently, the practice of watercolour will add to your strength and understanding of both subjects.

Paint

Watercolour paints are made from coloured pigments and gum arabic. They come in tubes or pans (blocks). A twelve half-pan pocket box with brush is extremely useful, and you can add to this as you go along. Choose according to how much paint you will require. There are various brands on the market, but always buy professional artists' paints, as the quality is far superior. Delicate or strong colours can be obtained by the amount of water you use. Test your colours before starting and try not to muddy the work by over-painting. Colours should look fresh and bright to the eye, like sparkling jewels. Make yourself a simple colour chart so you can easily choose which you need. Watercolour pencils are also an asset and can be

employed both for drawing and painting. Keep them well pointed for detail work.

Brushes

Sable hair is by far the best type of brush, and since you will probably only need three at the most, it would be good to invest in these. They are expensive, but if looked after will last a lifetime.

Always wash your brushes after use; rinse in water and then wash with soap (Sunlight is good), making sure you remove all trace of colour. Shape the brush, and stand it upright in a jar to dry.

If you are using synthetic brushes, the same principles apply.

Paper

You must use the correct paper. It is pointless to work on thin paper that is going to cockle and ruin your efforts. Watercolour glued blocks or spiral books are suitable for our purpose. Later on, if you want to work on a large scale you will have to learn how to do this and to stretch your paper. There are various weights of paper and the heaviest is more costly. A very popular weight is 140 lb, which is a good starting point. In time you will find your personal preference.

Techniques

The English school of watercolour is renowned for its technique, with the acknowledged master being J.M.W. Turner. This artist was able to achieve unbelievable results thanks to his total comprehension of the medium, soaring it to great heights of fame. His portrayals of light, space and the forces of nature defy description and laid the groundwork for Impressionism. With atmospheric effects and glorious mingling of colours, it is easy to understand why he is so esteemed.

Another expert in watercolour, but painting in quite a different way, was Helen Allingham. She became famous for her portrayal of English thatched cottages and farmhouses, scenes of the countryside and rural life, and elegant floral landscapes in pastel colours. In 1875 she became the first woman to be admitted to full membership of the Royal Watercolour Society. Marrying a man twice her age and having three children to support, she needed to earn an income from painting. For a woman to achieve such acclaim in the climate of the times was a true accomplishment.

There is a great deal to learn regarding watercolour painting, and there are many books on the subject. However, for the purpose of doing designs to ultimately transfer to our porcelain, we need only know the basics as an introduction to this fascinating medium.

How to work out a design

Turn your plate upside down on good tracing paper, draw the circle of the plate and cut out neatly. Fold the circle into twelve sections and crease sharply. Now lay your plate over your piece of watercolour paper and draw the circle. Place the template over the paper and mark where the lines will appear on the plate. With your ruler connect up the marks you have made, using a dot in the centre. If you have difficulty in transferring this graph to the paper freehand, draw over the folds on the tracing paper with your ruler and chinagraph pencil and transfer it to the paper in the usual fashion.

Now you are ready to design. Start each section of your drawing from the centre and work down. Keep very exact, as you will have to trace this and copy it into your other sections.

When utilizing a geometrical design, once your pattern is drawn and ready to paint you need only decide the colours you are going to use. Keep the mixture relatively dense so that you do not have to do too many coats. You will soon learn this method of filling in, but do keep in mind that the colours chosen will finally be from your mineral oxide paint.

Start by turning your plate upside down on your paper and draw the

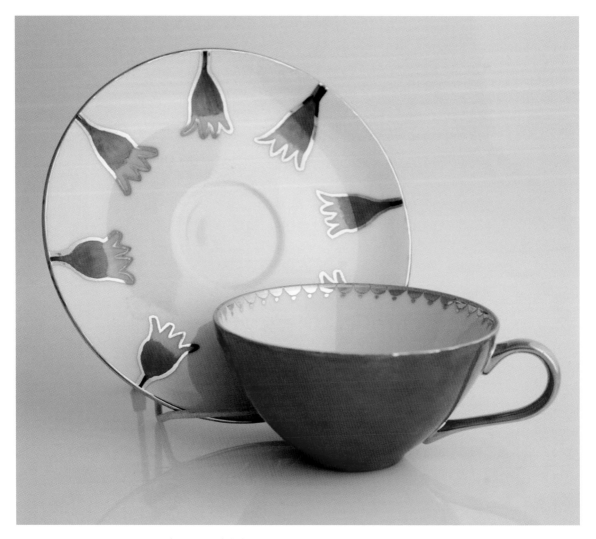

Cup and saucer with light red ground cup, original flower bell design on saucer, outlined and edged in best liquid bright gold, with freehand gold shell design around inside of cup and gold handle.

circle. Choose easy flowers to start with: pansies are a good example and quite often growing in the garden. A wild rose, with its five-petal outline, makes a charming border. Your design should be lightly drawn or sketched in with a sharply pointed hard lead pencil.

Study your example and choose the colour of your paint accordingly. For yellow pansies use a wash of pale yellow first, then, following the

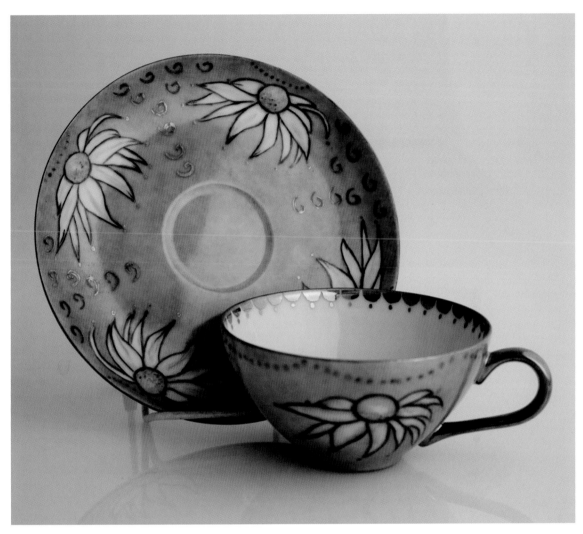

Cup and saucer with celadon ground colour, original flannel flower design pulled out of semi-dried background, best silver embellishments with freehand shell design around the inside of cup and silver handle.

colours of the flower, build up accordingly.

Continue in this fashion and keep your first piece simple; it is far better to progress slowly and gain confidence. Repetition of a motif is a necessary part of design: butterflies, insects, fruits and flowers all transpose well.

In the following pages you will find some designs for you to study and use if desired. Colour changes will make them your own.

Guidelines for painting yellow pansy in watercolour

Trace or sketch the pansy on to your watercolour paper. Following the main colour of the flower, first paint a wash of lemon yellow over the petals. Use a wad of tissues to dab up excess paint; do this just as you would when porcelain painting. Keep your highlights. Lightly outline the edge of your pansy with vermilion watercolour pencil. With a wet brush pick up on pencil lines and loosen the colour. Shade the fringe on the petals with orange, and touch of light red. The platform of the pansy is painted with orange, magenta and black whiskers.

If you are not happy with your result, wash the colour out with clean water on your brush and quickly dab up the excess and start again. A hairdryer is very useful and helps you to move quickly over the work and correct mistakes if necessary.

This design would work well on a small plate, or use as a centrepiece with additional scattered pansies.

Suggestions on designs

Creating a new design can be a challenging and exciting experience, but it does take time and much consideration. Perhaps this is the main reason why so many people choose to follow prepared ideas.

When you start ceramic painting, it is not only sensible but essential to have a good design to follow, even if it is only in black and white. But once you have become familiar with the mineral oxide colours and you know how they perform, it is time for you to be adventurous and experiment.

Possibly you are aiming to concentrate on floral decoration, whether it be roses, pansies or any other of your favourite flowers. Always try to think of a new way in which to present them: study the nature of the flower and consider the wide choice of styles that you have available to work with – conventional, naturalistic or abstract. If you have familiarized yourself with all of the chapters in this book, you will be aware of the vast opportunities

there are to make each piece of your hand-painted porcelain very individual – silver, gold, lustre, grounding, raised paste, as well as the actual painting in whichever method you have chosen to pursue. It may be the European, the Soft Look, the Wipe Out ... Turn the elegance of the past into the present and think about your design. Try to incorporate tradition with a modern approach.

Do not be afraid to be different, but make your own mark and don't be just a pale imitation of somebody else. For every tried and tested design that you paint, match it with a new exciting one of your own.

Let us start by working with a plate. And although this is usually round, that is not necessarily how the design also has to be. Get into the habit of

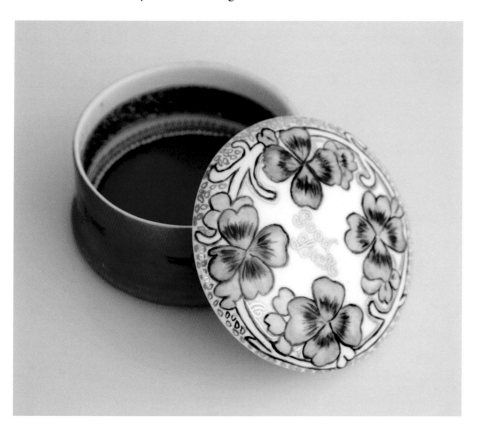

Small round trinket box, top decorated with original four-leaf-clover design and Good Luck in gold with embellishments. Bottom of box ground in green, and lined with green silk, ribbon, braid and pearls, with gold bows painted on the outside.

thinking about geometrical shapes – squares, oblongs, triangles, stripes, spots, zigzags of colour or just white reserves. The list is endless and the possibilities fascinating.

To start with, your design does not always have to be conventionally placed right in the middle of the plate. Sometimes it is more interesting to divide the rounded surface into parts, equal or unequal. It all depends on what you have in mind.

For the purpose of this exercise I am going to make a simple eight-section geometric design and show you how to work it out on a piece of white paper. You can then make a true copy of this on your tracing paper and transfer it to your plate in the manner previously explained. This design can be kept and then used in various ways, by changing the colours, or adding silver and gold or filling in panels with flowers or symbols. You can utilize it so that the design will never look the same. Alternatively you can do a matched pair of plates – or more if you wish. Once you have done your initial design you have it to preserve in your own file for your reference. In this way you will build up your library of original work.

Turn your medium-sized plate upside down on your piece of white drawing paper, and draw round the circumference. Repeat this operation on a separate piece of paper, one which you can fold easily and which is not too thick. Now carefully follow the line and cut this circle out. You will use it as a template for your design.

Fold the circle in half and place it on the bottom part of the drawing, making sure that you keep exactly on the lines. Carefully draw a line across, halving the circle. Now fold your template in quarters and mark your paper accordingly, including a centre dot. Make one more fold and draw in your lines. Once you have made the necessary marks on the paper you can use a plastic ruler if you wish, but be sure that your lines all run through the centre dot. You will see at a glance whether you have made the divisions equal.

Now you have your round divided up into eight sections of straight lines. Start working your design from the centre, keeping the stroke simple and short and working outwards, as shown in the example. This is going to be

half of the design. Now, with a piece of tracing paper and your chinagraph pencil, copy *exactly* what you have done. Carefully line it up on your drawing and transfer the outline in the way previously explained, so that it now appears on both sides of the line. Make sure you have lined it up correctly, so that it sits together evenly. Keep working in this fashion until you have a pleasing design on your circle. Doing it this way, you have a master copy on paper, which you can study and decide whether you want to make any alterations.

When you are satisfied with your results, place a clean piece of tracing paper over the design, and with your chinagraph pencil carefully copy your design so that you have it ready to transfer to your plate.

In the following pages you will find some simple designs to follow, and suggestions on how to complete them. But remember, designed plates are meant to have no brush strokes showing. The idea is to have pure little blocks of colour, or gold and silver adorning the white porcelain like sparkling jewels.

CHAPTER 8

PEN WORK

This is an area of porcelain painting which is quite often neglected, but it has its uses and if carried out correctly can enhance a piece of work with charm and character. Once you have got used to using a pen on the shiny surface of the glaze, you can draw anything that you like.

Quite often a geometrical design is completed by pen, then fired before the colour work is carried out. Black and white work is very effective when carried out in pen work alone, as is royal blue, which fires well and lends itself to the medium. A blue and white plate with a painted centre and a border of pen work is always very acceptable.

You will need ...

- Special pen oil.
- Special pen black powder paint (or a colour of your choice – royal blue and olive green are both solid, satisfactory colours).
- A mapping pen.
- Mineral turpentine.
- A tile to mix the paint on.
- A palette knife.

With your palette knife, take some of your powder paint and place it in a neat little pile on your work tile. Add a small amount of pen oil, but not quite half

and half. Stir the mixture together so that it binds, then add a little of your turps with the blade of your knife, making it into a good runny texture. It has to be a little thicker than ink, so that it is workable. If too thin, it will not hold the lines well.

Gently dip the tip of your mapping pen into the mixture, then draw your lines on the china in much the same way as you would if you were doing a pencil drawing. The nib will only hold so much mixture so you might have to dip in quite often, but do keep your lines joined. Remember, what you see is what you get. If you are following the pencil outline of your design, do not press down too hard but simply allow the nib to flow over the work. The pencil will fire out after firing. If you are doing a freehand drawing I suggest you do small strokes, as it takes practice to get a long flow.

Small flowers look very striking when worked by pen, especially buttercups and daisies or holly leaves, and berries surrounding a red robin, which has been carried out in traditional colours, with a circle of pen work, is really making your own statement.

You can also make little circles with your pen, some really small ones and then some a little bigger. Mix them all up into the background of a border, and in a monochrome design they will look quite stunning.

Once again, there are many ways in which you can incorporate pen work. For example, if you are disappointed with a flower painting that you have fired, try outlining the flowers in black or gold. This sometimes makes for a striking finish. You can use your pen in lots of unexpected ways, including signing your name.

Firing

Pen work is fired at 815°C. This is a high temperature, but the lines have to get beneath the glaze in one firing.

PORTRAIT PAINTING ON PORCELAIN

Before attempting portrait and figure work it is advisable to master easier branches of porcelain painting first. Be thoroughly conversant with your mineral oxide paint and all of the mediums that have to be used to get the particular result you want. The knowledge you gain from constant practice with your various brushes, silk pads and varieties of mediums will be your certain guide to success in this area of painting. You have to know what to expect from your colours and how to handle your work with confidence.

Portrait painting on porcelain is without doubt the top of the tree in this field, and classed as high art. Once again, if you start with a simple subject and master this, later on you will be able to portray any type of face you wish. It is a good idea to do a monochrome painting for your first attempt. Sepia, blue and white – in the manner of Delft – or soft grey will give you an opportunity to work easily and without the worry of multi-colours to contend with. Using only one colour will simplify the task and teach you the lights and darks, shapes and planes of the human face. Get into the habit of drawing features over and over. Practise depicting eyes in all shapes and sizes, mouths that are smiling or serious, hair that is curly or straight – little pencil sketches to familiarize you with structure. Don't be too ambitious when you first start: choose a flat surface to work on. A plate or a tile will be an excellent choice. Later, with experience, you can paint on anything you like, bearing in

mind that portrait painting is more suitable for one particular piece of porcelain than another.

A good black and white photograph of your subject is very necessary, and I suggest that you trace your model on to the plate for this first attempt. It is essential that the head be drawn correctly to start you off in the right direction. Make a perfect copy so that you can re-establish your lines after each firing. The first firing will have to be strong to guarantee a good glaze. It is a sensible idea to work on three plates at the same time when you first start, so you can then decide

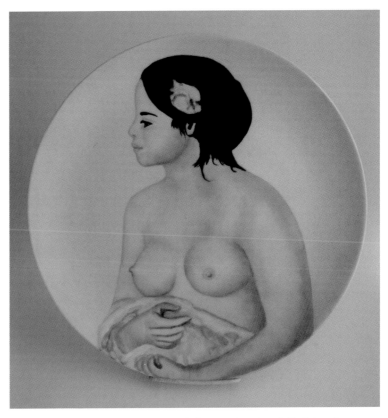

Hand-painted plate with 'Sicilian Girl' after Renoir using shell pink and grey with dark hair.

which is the best and fire that one. This is excellent practice, and since you are using only one colour there is no problem of waste.

When you have gained more experience you can sketch your portrait freehand if you so desire. When beginning this highly skilled art form, I suggest that you use copies from the oil paintings of the Old Masters. The *Mona Lisa* by Leonardo da Vinci is much admired and easily recognized. An accurate reproduction of such a famous painting would teach you how to handle not only facial composition – placement of eyes, nose, lips, the enigmatic smile, long dark hair, a veil and hands – but also a landscape in the background featuring many colours. A truly wonderful challenge.

Your self-esteem would rocket if you could manage to capture a good

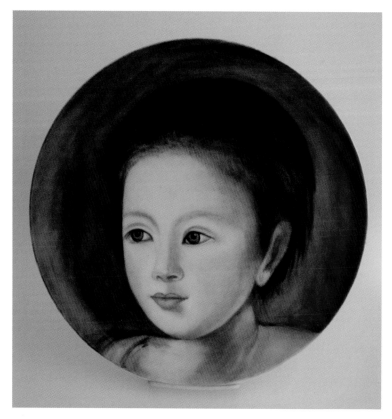

Hand-painted plate with portrait of his 'daughter' after Constable.

likeness. Confidence is needed in all spheres of painting, especially when using porcelain. Toothless and shiny, it is a difficult canvas to work on, so do not lose heart and abandon the project when things go wrong. Merely wipe the paint off and start again, until you are happy with what you see. Remember that there are no short cuts in porcelain painting.

In the past, professional portrait painters working for Meissen, Sèvres, KPM Royal Porcelain, Royal Vienna and Limoges, to name but a few, all copied their portraits from well-known oil-on-canvas works by famous artists such as Rembrandt van Rijn, Thomas Gainsborough and Anthony van Dyck. Their favourite subjects were beautiful women, royal children and romantic themes, with lavish decoration on quality porcelain, for presentations and for a wealthy private clientele.

Many fine oil-on-canvas artists turned to painting portraits on porcelain when the interest in canvas work declined in the late 1800s and early 1900s. The production of portrait painting on plates, vases, urns, cups and saucers, plaques, etc., was prolific. Today this hand-painted portrait work is much in demand and commands huge prices at auctions. Collectors yearn to own a piece of this special art form, and price seems to be no barrier as long as the work is top class. If this is to become your special field, study the classic work

in museums. Paint portraits of famous people that are recognizable and artistically executed. There is no substitute for quality, and the ability to render a true likeness is a talent to be fostered. It is a gift that is favoured to the few.

The ability to turn from one medium to another is a big asset. Once you have learned how to paint a portrait on porcelain, you can then decide whether you would like to try oil painting. Most portrait painters make good use of a camera when undertaking a likeness of their project. Take your own photographs of family and friends; make your own choice of subjects. Start slowly and take time to work your way up the ladder of success.

Today we are very fortunate to have the World Wide Web at our fingertips, via the computer. We can visit museums and see their collections without even leaving our homes. The Gilbert Collection in London is one of the few to concentrate on enamel art. Here you will find over a hundred examples of miniature portraits, exquisite work and a multitude of subjects.

The Wallace Collection and the National Portrait Gallery in London, the Usher Gallery in Lincoln, the Dyson Perrin Museum in Worcester, the Salting Collection in Hampstead and the Holburne Museum in Bath, all feature hand-painted porcelain, and the list is endless. Tap them up.

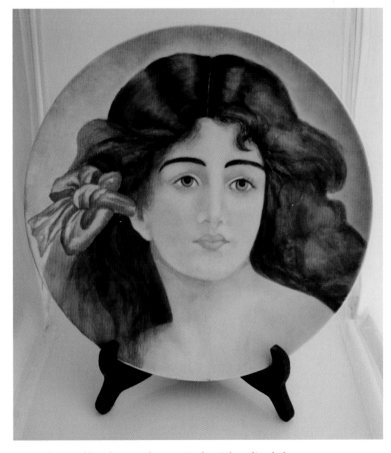

Large plaque of hand-painted portrait of an Edwardian lady.

95

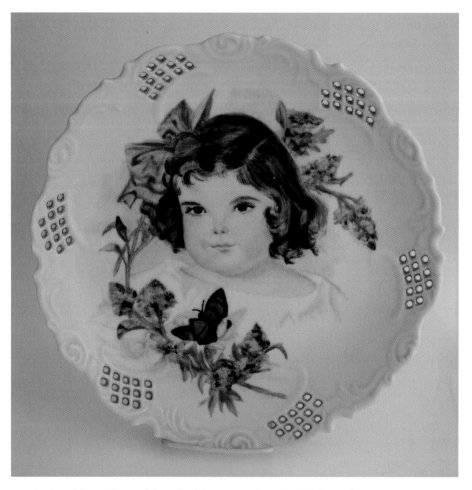

Hand-painted fancy plate with liquid gold inserts and a girl with a butterfly.

Miniature portrait painting is extremely exacting but has a large following and may well suit your ability. Why not try creating small works of art for tomorrow's collectors?

Whichever type of portrait painting you ultimately take up, the main thing is to enjoy it.

As with other areas of porcelain painting, there are many different techniques. In the following chapter I shall go step by step through the various ways in which I have achieved good results.

By now you have the necessary paint, brushes, stipplers, etc., and know

how to handle them. Do not use new brushes or new silk: worn-in, familiar equipment is by far the best for this work. You know what to expect from your favourite, well-conditioned brush and soft grainless silks. The last thing you want is pattern marks or streaks. These special attentions play a big part in all painting and ultimately in your end results.

Method

- Make a tracing of your subject and transfer it to your plate. Keep the outline strong so that you can easily follow the lines.
- Now mix one colour on your palette using an open medium, and one that is rather fluid. Have a generous amount of paint mixture ready to use.
- Have your silk pads and a very soft brush to hand.
- Have your black and white study in front of you to follow.
- Pick up your plate and look at it closely. Fill your silk pad with the paint mixture, checking that it is well mixed and has not separated. With light dabbing motions cover the head completely, making sure there are no areas left blank. Take a fresh pad and dab out the highlights, as on your photograph. Do not remove all of the paint, just sufficient to denote light and shade.
- Study the work and see if you are satisfied. If so, wipe out the whites of the eyes and remove the paint from the teeth if they are showing in a smile. Make sure to leave some paint between the teeth to give a natural look.
- The work will be drying, so move quickly. Now you can establish the eyeball by painting in the colour you are using. Don't forget to highlight. Take this out with your fine rubber-tipped paint remover or a similar tool (toothpick). Check the plate, making sure there are no particles or loose brush hairs adhering, then start on your next one. Continue in this fashion until you have one that you feel is good enough to fire.
- Do not hesitate to start all over again. Nobody can be perfect on the first trial. There must be no build-up of colour and no 'start' and 'stop' lines,

but the paint should be stronger in the deepest shadows, according to the shape of the face.

- If you have gone over the edge of the outline with paint, now is the time to gently remove it with a very fine tool and gum turpentine and regain the correct shape. Be very careful not to leave a build-up of paint, nor to remove too much.
- If you think the three plates are worth firing, do so; otherwise, pick the best one. Once the plate is fired, you have secured your drawing.

Second firing

Before starting work on your plate, give it a gentle rub with your much used and softened 00 sandpaper. The plate has to be completely smooth to the touch. Re-establish your tracing, making sure you have it in the correct place.

Since you are working in monochrome, mix up some more of your colour. You will use the same technique on the face, dabbing all over with a well-filled silk pad and taking out the highlights again, but this time you will incorporate painting the hair with a stronger mix of your colour and using your brush according to the way the hair appears – curly, straight … The lips, eyes and eyebrows can now be painted into shape. Try to work quickly and always dab to keep the work soft and blended.

You will find it easier to work with one colour and will readily see where to build up your shadows and get a likeness of your model.

Don't worry if this piece is not perfect: it takes a lot of practice to use open paint and incorporate the brush and silk pad, but it will come with experience.

Third firing

- Sandpaper.
- Re-establish the face.
- Strengthen all areas that require it.

- Try and get some feeling into the work, i.e. expression and character.

You may need a fourth firing – don't skimp on firing to get the best possible result.

Keep these plates and refer to them when you start with your colours.

Colour work

There are usually sets of figure and portrait colours available expressly for this type of work. These have been tried and tested, with

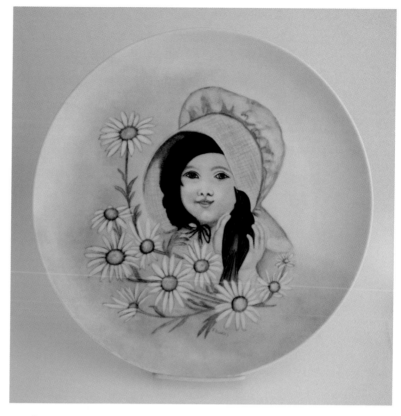

Hand-painted plate with portrait of a girl in a bonnet with daisies.

good results, an excellent way for a beginner to start. However, the colours you already have may be sufficient; it will really depend on your chosen study. Pompadour, yellow-red, flesh pink, yellow-brown, yellow-green, yellow-blue, hair-brown, finishing-brown, iron-red and a good yellow may all be needed, so gather your colours as you proceed and build up a good selection.

Transfer your model on to the porcelain.

Work out all the colours you are going to use before you start. You do not want to be mixing once you begin.

Place your chosen colours out ready to use on your palette, plus some medium. Continue as before, pad and silk, dabbing a light flesh tone all over the face, or alternatively brush it on and then use a dabber. By now you should have made your own choice as to which method suits you. Take out your

facial highlights as before, and while the work is still damp add the flesh shadows very carefully in their respective places, using a small stippler; then blend lightly. Use your silk pad to keep it smooth at all times. Don't lay any colours on too strongly – the first firing has to be even, with no outstanding patches. Remove any flesh colour from the lips and paint them with a light pompadour, the eyes with the colour shown in the study, and the hair, etc., in its correct shade and shape. Retain the whites of the eyes and take out your highlight.

Having first done your monochrome you will find this colour work less daunting. You can adjust your paint mix to your chosen method. It really depends on how large or small your portrait is as to which tools you use to apply the paint.

Check your work for dust, hairs, etc., and fingermarks on the back, and immediately place it in a box or carefully seal it with cling-film ready for a hard firing, which should bring up a nice gloss. Don't forget that the top of the kiln is the hottest, and you need a good gloss on all firings.

Second painting

- Sandpaper.
- Re-establish your drawing. Every care must be given to eyes, nose and mouth, etc. Make sure they are all correctly placed.

Work on the shadows in your colours, incorporating flesh colour. Follow your study closely, keep everything even and connected, with no 'stop' and 'start' marks, keeping your silk pad and a very soft brush on the go together. Make sure there is enough colour to give life to the subject. Constantly watch the highlights, as you won't be able to get them back if you paint over them.

Make it a habit to keep automatically checking for dust, hairs, etc., before firing.

What you see is what you get. Fire high.

Third painting

- Sandpaper.
- Re-establish the design if necessary.

Now that the work is taking shape you can model in the local flesh tones, using colours such as flesh pink and thin pompadour or yellow-red on the brighter parts of the cheek, but make sure it looks natural. Study your highlights, and if they are too severe in contrast, dab lightly with your flesh colour and then lift a little, leaving a thin coat. Remember it is always thin coats of paint, allowing each one to fuse into the porcelain when fired, layer on layer.

Strengthen all weak colour tones. Work on the eyes, eyebrows, nose, nostrils, lips, hair. Keep it soft and blended.

Check for cleanliness. Use a lighter fire if gloss and colour have been retained.

Fourth firing

Most portraits require a fourth firing.

- Sandpaper.
- Re-establish if necessary, although by this stage you should have a good likeness of your study to follow, fired on your plate.
- Sharpen up your shadows; a good mix is one part yellow-brown, one part yellow-green, a quarter part turquoise, or continue with the shading colours you have been using. Show the form by modelling where needed, but keep it harmonious, blended all together. No strong colours should stand out on their own. Squint your eyes to see if it looks uniform. Work on all the necessary areas – eyes, nose, nostrils, lips, hair. Keep your highlights bright but not too stark.

Your work should be ready for the last fire.

Clean-up check.

Sign your work.

Don't forget a light rub of sandpaper when it comes out of the kiln.

Ultimately each portrait painter has to decide which method they are going to use to accomplish their best results – wet-in-wet dabbing and blending, square shader brushes pulling colours into each other, soft stipplers slowly blending the tones.

Practice is the key.

Perfection is the aim.

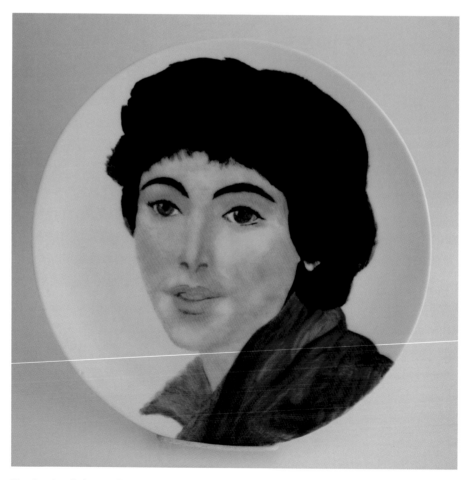

Hand-painted plate with portrait of a girl with green eyes.

Note

Particular attention must be given to the firing process for portraits. This can make all the difference between an excellent painting and a failure. Delicate colours applied very thinly may require even more firings to achieve your best result. To preserve the gloss you need a strong fire; to keep the colours you need a light fire. So start with a hot fire first and second, and lessen the heat with each subsequent fire to maintain the new application of colour. You will have to be the judge when it comes out of the kiln as to whether it requires a stronger heat to fuse. Firing of the kiln is *very* important.

Miniature portraits

This undertaking is entirely different and requires good eyesight, a magnifying glass and an erasing pin. This is a favourite area for reproducing much-loved children or family members – treasured mementos that will last for ever, a tour de force for romantic themes. Keep a figure and portrait set of colours exclusively for this subject.

Balsam of copaiba oil is a well-used medium for this type of art, or use one of a similar texture, together with pure gum turpentine. Painting a small area you have to be precise: a good outline is essential in a controlled space. Transfer your portrait on to the medallion in the same fashion as before, giving particular attention to the eyes at all times. Eyes are the main focus in portraits. Establish their colour and pull out the highlights immediately.

Use your colour in the European Style, meaning that your paint starts off with a thin, smooth undercoat, and when it is dry you paint over the top without firing. It takes a lot of skill not to lift the under-paint, but requires less kiln use. Small, soft stippler brushes and fine pointers are required. This is a painstaking procedure, but if mastered has the advantage of seeing the portrait readily come to fruition.

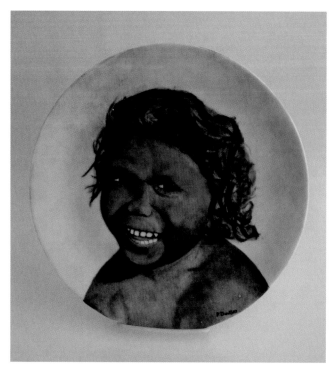

Hand-painted plate of laughing boy in monotone colours.

If you cannot handle this technique, fire your work at each stage in the usual way. However, it is worth practising this method of shading on unfired undercoat, waiting for the paint to dry from one day to the next, as you may be able to complete your piece in three firings.

Keep your paint fresh and work from the edge using tiny mounds of colour from light to dark, from left to right, adding just a smear of pure gum turpentine when the mixture gets thick.

Everything is scaled down to work precisely over a minute area. A small tile is a useful palette; keep everything neat and tidy.

If possible, work the first painting in complete detail, using all the colours you require to capture the likeness on the first firing. Make sure to keep your highlights, where necessary.

Grids have long been a popular aid to drawing more accurately. By placing the traced grid over the study you wish to copy, you can match up each square and break down the picture into sections. You will readily see the result and the amount of space left around your model. This was a common method used by the Old Masters, who would make a small drawing and enlarge it on their grid, and the practice is still carried out today for all types of art work. The more squares, the easier it will be to see where to paint your portrait. Draw your own grid to whatever size squares you want. Large or small, it is excellent practice to merely study the placement and get an idea of how it is going to appear on your chosen piece, to ensure it is perfect for your portrait.

Portraits look very effective when used as centrepieces on round objects, but are not easy to handle. Make sure you have an excellent drawing and that it does not move.

There is only so much advice to be given: the rest must come from trial and error. Be prepared to do some copy work from Old Master portraits; this is necessary to become technically proficient. Then venture out in your own style, allowing your comprehension of the subject and originality to shine through your artistic endeavours.

It is true to say that gaining more knowledge about porcelain painting and the way it is created can only enhance your appreciation and desire for the continuation of this beautiful, intricate art form.

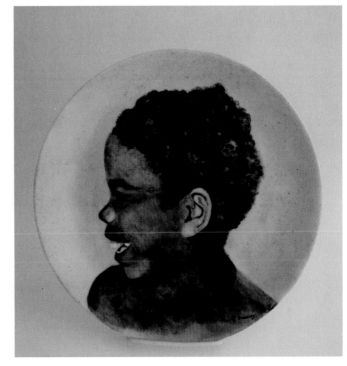

Hand-painted plate of laughing girl in monotone colours.

CHAPTER 10

LANDSCAPE PAINTING

The most well-known landscape image on porcelain is the Willow Pattern. This much-loved blue and white decoration is instantly recognized. Its intriguing classic Chinese landscape design incorporates a weeping willow, pagodas, a crooked fence, a tree bearing fruit, three or four figures on a bridge, a boat and a pair of lovebirds, forever kissing, and its romantic tale of forbidden love and star-crossed lovers appeals to the imagination of all viewers. Blending these ingredients, the romantic saga unfolds:

> Long ago, a rich and mighty Mandarin lived with his beautiful daughter Knoon-se in a magnificent palace surrounded by flowers, trees and sweet singing birds. The exquisite Knoon-se falls in love with a handsome young man named Chang, who is her father's secretary. He reciprocates her affection, and the two lovers meet each evening beneath a weeping willow tree by the river.
>
> When the Mandarin learns that his adored daughter has fallen in love with a commoner, he is devastated. He dismisses Chang immediately from the estate and imprisons Knoon-se in a pavilion overlooking the river. To keep the lovers apart he builds a crooked fence surrounding the palace grounds. His plan is for his daughter to marry the powerful warrior Duke Ta-jin.
>
> Alone apart from servants, Knoon-se feeds and talks to the numerous birds that have befriended her. She knows her wedding will take place when the fruit tree outside her window is in bloom.
>
> Lovesick Chang also speaks to the birds, dreaming up ways to reach his lost

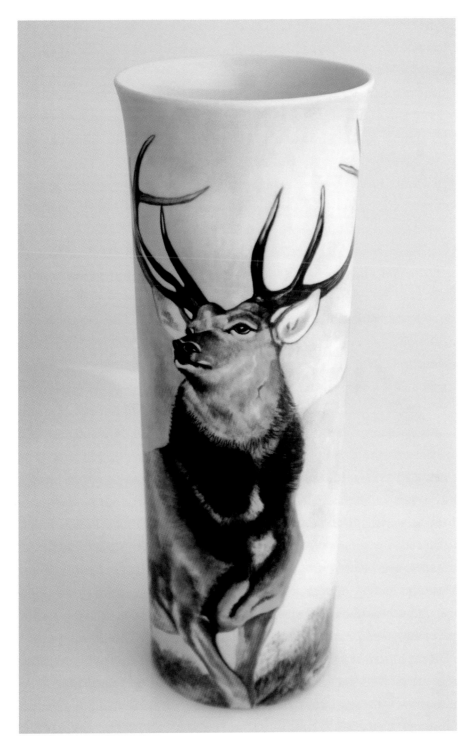

Kaiser porcelain vase
with finely painted
reproduction of
Landseer's 'Monarch
of The Glen in
landscape'.

love. They communicate using their feathered friends as go-betweens.

The tree is heavy in bud and about to blossom as Duke Ta-jin arrives to claim his bride, bearing a casket of priceless jewels that he presents to his betrothed as a gift. The wedding is to take place on the day the blossom falls from the fruit tree. Meanwhile, there are nights of sumptuous feasting and celebration, during which Chang slips into the palace unnoticed, disguised as a servant.

While the Mandarin and the Duke are fast asleep, recovering from their revelry, Chang creeps to the riverside apartment where Knoon-se languishes alone. The lovers embrace amid tears of joy and vow never to part. Pausing only to pick up the casket of jewels, they flee to the bridge and a waiting boat that Chang has in readiness for their escape. Alas, the alarm is raised and the Mandarin gives chase as they cross the bridge.

In the pattern, Knoon-se is seen holding the staff of virginity, Chang carries the box of jewels and the Mandarin, in hot pursuit, brandishes a whip. When a fourth figure is shown on the design, it represents the Duke, desperate to recapture his bride-to-be.

The lovers sail away to a faraway land where they sell the jewels, purchase a small pagoda and live in bliss for many years. Meanwhile, the spiteful Mandarin captures and cages all of the birds in his garden. Birdsong is the last thing he wants to hear. Obsessed by the loss of his daughter, he and the Duke continue to send spies and warriors on long journeys to find them. Suddenly, in a fit of inspiration it occurs to him to release the birds, and he orders his soldiers to follow them as they fly away. The delighted birds still remember Knoon-se and Chang, and unwittingly lead the evil warriors straight to their hiding place.

Orders are given by the wicked Mandarin to set the pagoda alight, and the doomed lovers perish in the fire, locked in each other's arms. However, the gods, moved by the couple's devotion and undying love, grant them immortality. From the ruins of their charred home, the souls of Knoon-se and Chang are set free and soar into the sky as turtle-doves. They are portrayed flying together with outstretched wings and kissing, symbolizing eternal love.

As with all legends over the years, different versions of the story emerge. However, nothing can change the fact that the Willow Landscape pattern is still popular today and highly desirable, with a huge following of avid collectors worldwide.

The original engravings of the Chinese Willow Landscape were by Thomas Minton for Thomas Turner of Caughley, Shropshire, in the year 1780. Two of his lesser-known patterns were named Willow-Nankin and Broseley. These designs had no bridge with people crossing over it, and no story to add to their fascination. The traditional Willow Pattern as we know it was first produced in 1790 and attributed to Josiah Spode. Established potters such as Royal Worcester, Adams, Wedgwood, Davenport, Clews, Leeds and Swansea closely followed. Transfer printing from engraved copper plates had arrived, allowing mass production on a large scale. It is by virtue of some very clever marketing, plus the addition of a romantic fable with overtones of doomed love and tragedy in true Shakespearean fashion, that this distinctive landscape has not been out of production ever since.

By 1830, there were approximately two hundred makers of Blue Willow in England, and the modern blue and white Willow executed by Burleigh of Stoke-on-Trent is still popular today.

At the end of the nineteenth century it was produced not only in the UK but all over Europe, including Russia. The American market had also increased, and they too began mass-producing transfer print wares to satisfy the demand, so the need to laboriously hand-paint the Willow Pattern and other popular designs of the day, such as floral decoration, portraits, pastoral and landscape scenes, was eliminated.

This was not the situation for hand-painted work in general, especially in the case of landscape painting. Picturesque scenes and architectural buildings such as Windsor Castle, notable cathedrals, and prominent London and Scottish landmarks were extremely popular and much in demand. Many of these works were grand presentation pieces or for international exhibitions, to promote the factory and show off the skill and capability of its artists. Top-quality handwork was therefore still essential.

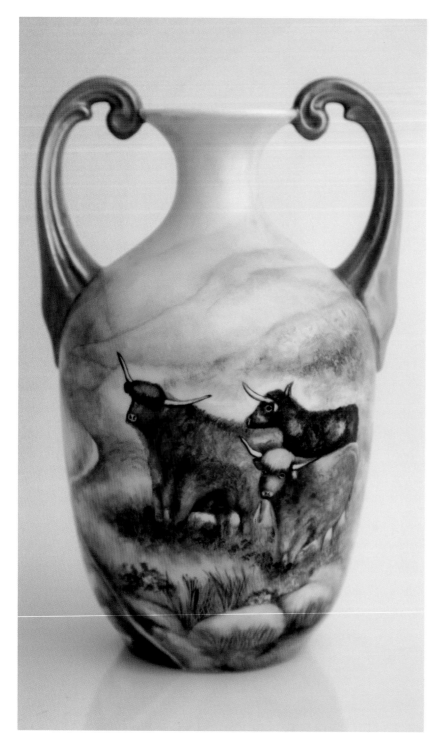

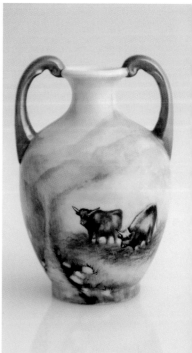

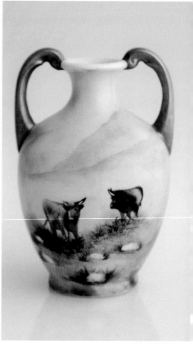

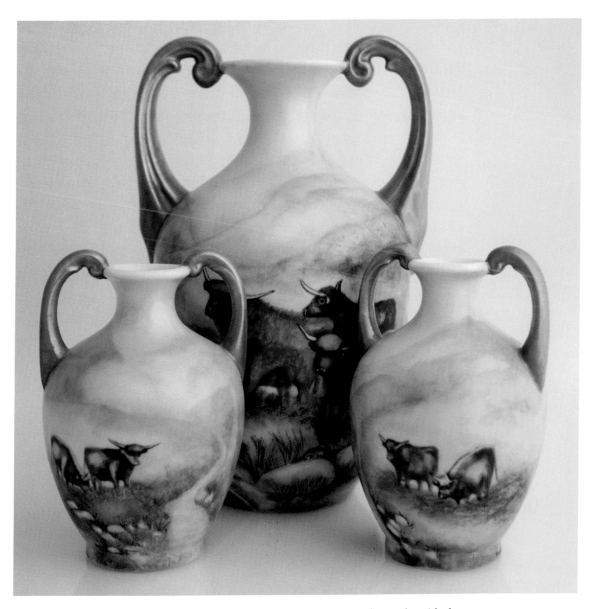

Far left: Large porcelain vase with freehand-painted Highland cattle scene, plus two burnished gold handles. Front.

Top left: Small porcelain vase with freehand-painted Highland cattle scene, plus two burnished gold handles. Front.

Bottom left: Small porcelain vase with freehand-painted Highland cattle scene, plus two burnished gold handles. Back.

Above: Garniture of three handled porcelain vases with freehand-painted Highland cattle scene, with burnished gold handles. The Set.

Ceramic artists became renowned for their fine and exquisite work in reproducing Old Master landscape paintings, with source material coming from such artists as Turner, Landseer, Constable and Corot, plus the occasional fantasy landscape with exotic birds, together with original work taken from the ceramic artists' own watercolours and oil paintings of favourite scenes.

From the 1780s onward, Royal Worcester produced some magnificent pieces by Thomas Baxter, William Doe, Thomas Rogers, Harry Stinton, John Stinton and Harry Davis, to name but a few, all specializing in the area of landscape painting on porcelain. Not only did the artist have to reproduce a likeness to the composition being copied, but he also needed to alter the proportions to fit the object he was adorning, whether it was cups and saucers, jugs, plaques or vases. Talented artists had to learn how to adjust paintings to the curved surfaces to avoid distortion and retain a recognizable image. Most reputable porcelain manufacturers around the world had their own gifted artists. Their technical excellence was – and still is – impressive.

Those of us who practise this all-absorbing art form and know the intricacies of working on porcelain have nothing but admiration for these trail-blazers of the past and their ability to produce such outstanding works of beauty. Not only was their effort superlative, but their love and dedication to the craft shines through.

Create your own memorable landscape painting. Spode has the Willow Pattern, Constable *The Hay Wain*, Monet his water lilies. I have a series of 'Happy Plates' designed to make you smile.

Landscape is yet another fascinating area for porcelain artists.

Requirements for painting landscapes

- A good-sized plate, plaque or tiles.
- A full palette of colours and your particular medium.
- All of your available brushes and silk pads.

- A simple study, or a photograph of a favourite landscape to work from.
- Pure gum turpentine, and the necessary equipment always required.
- Cleanliness at all times.

General advice and guidelines on painting landscapes

Landscapes and a never-ending change of scene surround us as Mother Nature takes us through the seasons. Some are soft and gentle, and others more rugged. We all have a particular view that we would like to capture, or a special location that conjures up memories, both for ourselves and for others like-minded. Landscape paintings are a popular subject, and when competently painted are well received and top-sellers on the open market. Here are some suggestions to help you succeed in this area.

Perspective
This is the art of viewing a picture from a specific point, its lines and distance.

Horizon
This is the line at which earth and sky appear to meet. Establish your eye level by holding a book vertically in front of you, with your hand outstretched. Raise it gradually, and when you cannot see the top you have reached your eye level. It is not a good idea to have your horizon in the middle of your painting. Place it above or below. The more foreground, the higher your horizon; for a large dramatic sky and little foreground, vice versa.

Distance
Everything in a landscape becomes smaller as it moves into the distance. Objects appear less sharp and become shapes and outlines. Colour is less prominent and the atmosphere causes a misty look. We have strong colours in the foreground, half-tones in the middle and a pale, hazy horizon.

Composition

Do not put everything you see into your picture; squint your eyes and eliminate the non-essentials. In other words, compose the picture to your own liking, moving things around if necessary. Try not to make it even-looking – for instance, have three trees, not two, and keep the features to an odd number.

When working from a photograph take out any clutter: streamline the look. Simplify and draw the viewer's eye into the main focus point. Strong detail is in the foreground, with less emphasis as you work towards the background. Keep the painting blended, with no hard lines, as it appears in nature. The variation in your application of paint will help the viewer to scan the picture as a whole.

If you are including a road or country lane, make sure that it curves and narrows as it disappears to the vanishing point on the horizon.

Remember that clouds have no boundaries but appear fluffy like cotton wool, scudding across the sky.

Don't forget to leave gaps in the trees for the birds to fly in and out.

Above all, always paint what appeals to you, and your pleasure will show in the quality of your finished art work.

It is by far the best idea to practise in one colour, applied softly and airily in the fashion of an under-painting. This will give you more knowledge of light and shade, various tones and values. When you have completed a monotone you are satisfied with, fire the piece and then add some colour.

Landscape painting should be attempted only after you have acquired some knowledge of 'laying in' large areas of the mineral oxide paint. It is a great advantage to have done some watercolour painting, to prepare yourself for the method of soft washes of colour for the first firing of the under-painting.

Picturesque scenes can be captured either by painting a *plein air* landscape or decorative building by hand, or alternatively with a camera. Ideally a small sketch of your subject in watercolour, or some other medium, is preferable. However, if this is not possible or practical it should not prevent you from attempting a landscape.

When painting on location always use a viewfinder. This acts as a small picture frame, and you can make your own by cutting the centre from a piece of firm cardboard. Make various shapes – round, square, oblong. This will help you to adjust your picture to your piece of porcelain. Hold the viewfinder at arm's length and at eye level. Move it around the scene to get the best setting.

As previously discussed, past professional ceramic artists reproduced landscape paintings from master copies. This is extremely good practice. Not only will you learn composition, but it will also teach you to choose the

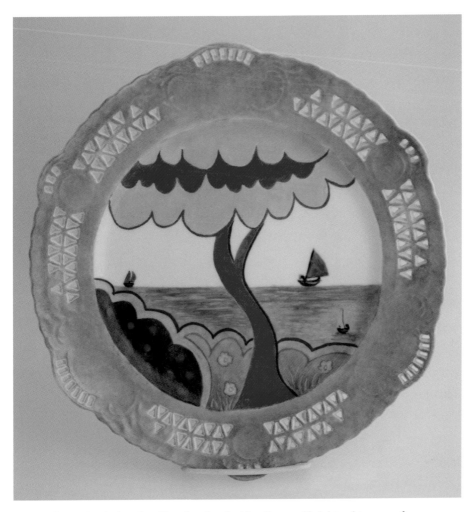

Happy Plate series designed and hand-painted with yellow and bright red tree on a fancy porcelain pierced plate with soft lilac border.

115

correct colours to use. There is a large range of tones in oxides, simply because they cannot be intermixed (unless otherwise stated by the manufacturer). With other paint such as oil or watercolour, mixing blue and yellow together makes green, red and blue create purple, and so on. It is not possible to do this in porcelain painting, so a broad knowledge of available colours and their uses has to be gained by experience. Red fades, green becomes stronger – make notes and refer to them.

We are fortunate that there is a large range and many hues to choose from, and it is good to take advantage of this selection and vary your tones of blue, green or yellow. Build up your stock, experiment, be adventurous, and give your work that extra edge!

Exercise

I have the study of John Constable's painting *The Cottage in a Cornfield*. I am not going to slavishly copy this to perfection – I intend to simplify it by leaving out the donkey and the bird in the foreground, otherwise it is a perfect example to start with. It has a large sky, a tree on the right-hand side, a gate in the foreground, a simple thatched cottage, well placed in a glowing cornfield, and in the distance there is a show of trees.

Loosely sketch in the outline of the drawing on to your porcelain, using your chinagraph pencil: first the cottage, then the trees, fence and gate. With your sepia, lightly go over your drawing, indicating your horizon and the distant trees.

Working from the top left-hand side towards the right and with a broad brush, apply a thin application of paint for the sky. If you prefer, this may be done with a silk pad and the paint carried over the outline of the tree. The choice depends on your preference and ability. Remember that the sky has to be stronger at the top and lighter at the horizon.

With a clean brush or pad, whichever you are using, remove some of the paint to indicate the clouds. Work quickly so that the paint does not settle and become difficult to move, blending all the time to give a soft airy look. This becomes easier with practice. Now work on the cottage with your paint

a little stiffer. Complete this before you lightly block in the distant trees. The cornfield, the foreground and the area through the gate are a similar tone. Brush or pad these in. Next, work on the tree, making sure that it is not too heavy. If you are using a plate, bend the tree to fit, keeping its distinctive shape. Paint in the fence and the gate and all the shadows.

Your sketch should be totally covered. Examine your study and look for the highlights. There are many: the side of the tree, the thatch, the gate, flowers … Carefully take these out now with a turps brush or erasing rubber pencil. Some artists use a medium or a fine brush. Remember, you will not be able to feature them so well once your piece is fired.

The sepia under-painting should now be ready for a first high firing. If you are not satisfied with the look of it, wipe it off and start again. Practice is the key with all painting.

If you wish, you may now colour this work. It will not look exactly like the study, but it will give you an opportunity to experiment. The main object is to flow your paint where necessary, without making harsh lines. If you paint too heavily it is liable to chip off. Use this work as a guideline.

First firing for colour work

Remember that in all of your painting, the first work must be a high fire. You will lose some initial colour, but it will make the end product smooth to the touch and professional-looking. Thin washes of colour are the keyword, and in this way you are able to correct your mistakes as you go along. If the work is light and airy, you have an opportunity to change your mind regarding your composition.

Second firing

Strengthen all the colour tints. Keep your highlights. Work from the top downwards – light, medium, dark. Make sure that the picture harmonizes with an artistic effect, and not in the manner of a photograph. You have to get

a 'feel' for the painting when you are doing landscape. Keep looking at the work as a whole, considering form and shape. Skies are never really blue and white; they have a multitude of colours throughout. Pink, blue, purple, violet of iron – all of these colours are used to create a misty atmosphere. The more you experiment, the more you will learn.

Constant attention should be given to the foreground. This is an important area, and after your under-coat has been fired select the richest tones to match the shadows so that they stand out. You want to reach the same level of painting at the same time. Usually four firings are required if many colours are used. However, do not skimp on firing, especially with your first landscape.

Summing up

You will learn an enormous amount about landscape painting if you go slowly and have a full palette. Note the colours that you have used and how they work in your particular treatment. Soft purple tones over green are good for middle distance. The atmosphere can be obtained by use of sky blue, light purple and a little black, well blended. Your horizon will benefit from an undercoat of pale yellow, with overtones of flesh and light yellow-brown softly merged into one another with your pad.

Reflections from the sky on your subject always have to be featured in your picture. If it is a bright sunny day use warm tones to retouch your green and other lighted areas – yellow-brown is ideal for this. A colder sky is shown by the addition of blue or blue-grey.

A test tile showing the results of your layered colours after firing is a wonderful tool, and well worth doing.

Suggested colours to use for this study

* Sky: dove grey, sky blue and black, with a touch of pale lemon in the horizon.

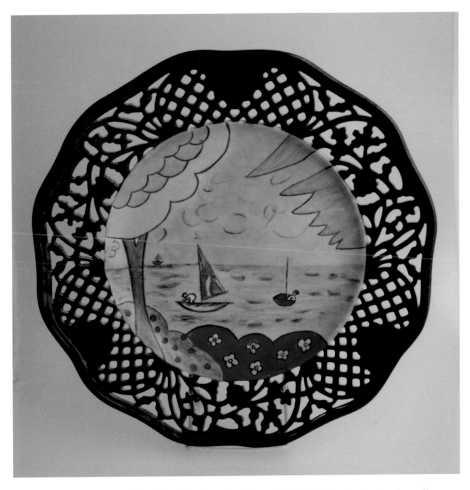

Happy Plate series designed and hand-painted on decorative lattice blue lustre border, yellow tree and sailing boats.

- Cottage: golden brown, yellow-brown, yellow ochre, dark brown, light purple.
- Cornfield: primrose yellow, lemon yellow, old gold.
- Tree: lemon yellow, yellow-green, yellow-brown, shading green, deep brown, rich brown, black.
- Fence and gate: dove grey, light purple, rich brown.
- Foreground: primrose yellow, lemon yellow, old gold, rich brown, light purple.

119

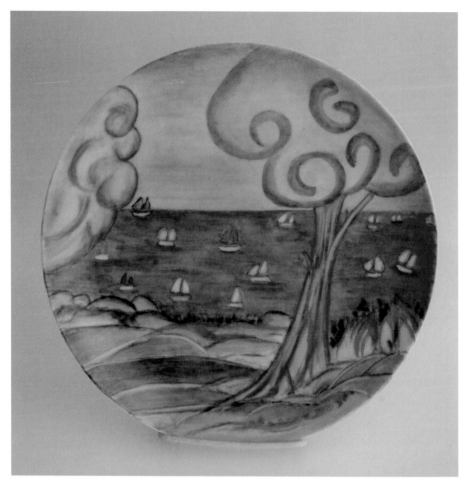

Happy Plate series designed and hand-painted with turquoise and pink trees with sailing boats with full use of enamel colours.

Contemporary landscapes

This is an entirely different field, but one that is very popular. There will always be a following for traditional landscapes, but styles in art constantly change and it is refreshing to see new ideas.

Naive painting functions very well on porcelain. A whimsical design can bring a smile to the face, and leave a lasting impression.

We are all very different and our tastes reflect this – especially in art. So

do let your imagination run riot. Fun-filled landscapes are just that – fantasy trees of many colours, matchstick people, larger-than-life flowers – it entirely works in art. So dare to be different. You can break all the rules. Use beautiful pure colours to their best advantage. Orange, red, purple – choose the colours you do not normally use in a landscape and in this way you will see how they fire.

Seascapes

Here is an area that was very popular in the Victorian era: seafaring pictures encompassing romantic scenes of sailing ships hovering in golden-lit sunsets; moonlit skies with silver-blue clouds and shimmering water; small craft bobbing around on the horizon, with a foreground of golden sand and frothy water; interesting compositions of rugged rocks, with colourful seas pounding over them.

Porcelain painting is a decorative art form with an opportunity for you to get your viewer emotionally involved. The painters of the Victorian era were expert at this. What could be more sentimental than seeing a ship sail away into a misty sunset?

Now is the time to use all your glorious colours: skies ablaze with lavender, pink, orange and deep yellow, and a whole range of blues and greens for the sea.

Exercise

Sketch in your main sailing boat and commence painting, with thin washes of colour on the sails and boat. Let this partially dry. Then paint the sky, working downwards, left to right, as before on your landscape. A low horizon is very effective, with the sails of the boat high in the sky.

Remember that the colours of the sky are to be reflected in the sea. This makes for a beautiful painting, with movement in the water created by your erasing brush or rubber.

Work slowly, and use your silk pad to even out the colour. For your first

firing the paint must be light and thin. The second work will establish all your distant images. Keep your tones soft and harmonious.

The experienced porcelain painter will be able to work on the over-painting by strengthening some of the colours while wet. Otherwise keep firing and build up the picture gradually in the usual manner.

CHAPTER 11

CATS AND DOGS

Cats in art – past and present

The Ancient Egyptians first started the love affair with cats, and humankind's fascination seems only to have grown over the four thousand years of their domestication. Beautiful cats, strong and elegant, reign supreme, with their enigmatic eyes and independent posture as they walk into your life and take over.

Such was the case for the Egyptians, who were swift to realize the value of these godlike creatures as they quickly took up residence, and proceeded to safeguard their precious grain and other food supplies. It was not long before clever Puss was being revered and worshipped as gods and goddesses. The death penalty was soon imposed for killing a cat, and export of these precious creatures was forbidden. Mummified after death, they were buried in sanctified plots with their own store of mummified mice for the afterlife. Little wonder cats have a superior attitude, as they gaze back at us with knowing eyes from every form of art and literature in which they appear. These much loved refined feline creatures, with scrupulous habits of cleanliness and care, seem to have the ability to see beyond eternity as they quietly purr and entwine their way into your heart.

Not only are cats reproduced in every fashion, they now have their own feline art galleries around the world, displaying paintings and effects created by cats. Long venerated and considered protectors of the earthly spirit, they

are here to perform as sacred guides in the next world. Cherished cat paws strut their way over the canvas to reveal their artistic expression, leaving trails of colour, paw impressions and scratch marks of intricate design.

Viewers of these wondrous visions are keen to interpret their message, while renowned cat artists give first-hand advice regarding painting techniques and present other cats with positive role models. With a swish of an aristocratic tail and a twinkle in the eye, regal Puss performs his role with finesse.

Cat-lovers will be familiar with Louis Wain, an English artist best known for his pictures of cats in human clothes and engaged in human activity, as well as humorous cats fat and happy, surrounded by all the good things in life. In 1886 the painting entitled *A Kitten's Christmas Party* depicted 150 cats sending invitations, playing games, making speeches, there being eleven panels of cat paintings in total. It was published in the Christmas issue of the *Illustrated London News* and set Wain up for life in reproducing cats in every way, shape and form: whether playing golf in a kilt or singing in a choir, strumming musical instruments, serving tea, fishing, smoking or enjoying a night at the opera, Wain illustrated them all. Cats began to walk upright, smile widely and use exaggerated facial expressions, while wearing the sophisticated clothing of the day. The painting and drawing of cats proceeded to take over his life for the next thirty years.

Victorian England was amused and could not get enough of this talented artist's work. He was published in papers, journals, magazines, greeting cards and children's books, including the *Louis Wain Annual*, which was in production from 1901 to 1915, and he would happily parody human behaviour and satirize fashion and the fads of the times, to the delight of his captivated audience. Louis Wain was loved by all.

President of the National Cat Club and Chairman of the Committee for as long as he was able, he was a true cat-lover, gentle in disposition, but not a good businessman. He began to suffer financial difficulties, and by the time the war of 1914–18 was over his resources had dwindled, causing him a physical and mental breakdown.

Sadly Louis Wain was to end his life in a mental asylum, diagnosed with schizophrenia. He was still able to paint cats but they took on a different look, more abstract in fashion and known as his 'wallpaper cats' because of the multi-coloured patterns that featured in the backgrounds. Much has been written about this gifted man, who devoted his life to cats, and books of his work and life story abound. His art is highly collectable and much sought after by those devoted to cats and the humorous way in which he depicted them.

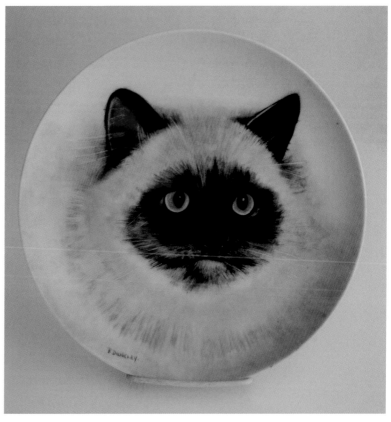

Medium-size porcelain plate with softly painted Siamese Blue Cat.

Our love affair with these small furry animals continued with such characters as Felix the Cat. Displaying his pure black fur, bright white markings, broad smile and crazy behaviour, he rocketed to fame as the world's most popular cartoon character, and later appeared in a series of comic books and English Sunday newspapers.

Animated cats were all the rage as Tom and Jerry chased across the screen and proved a very popular source of entertainment for the public. Sylvester the cat with his special voice and zany humour followed them, and he maintained the fascination.

The book called *The Cat in the Hat*, written fifty years ago by Dr Seuss, is still going strong. This tall thin sophisticated cat with a red and white striped

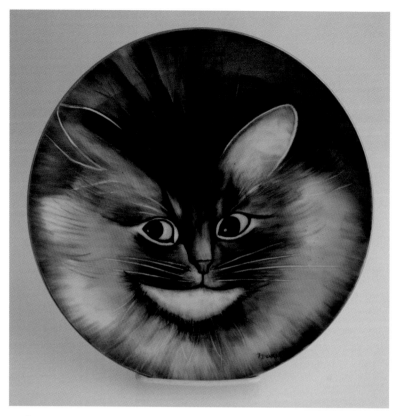

Medium-size porcelain plate with yellow and black fluffy painted cat.

hat is loved by children and recognized by all.

It would appear that cats besot us. The live musical performance of T. S. Eliot's *Old Possum's Book of Practical Cats*, with its assortment of highly individual painted cats with dandy names, has been on the stage for the last twenty-five years and is still going strong. Garfield is the cat in modern art, a deep orange tabby cat with large googly eyes. Digitally created and easily recognized by his fat fun figure, he is full of mischief and make-believe, as he talks to us in his own special voice.

If cats are your particular favourite you have picked an extremely popular subject. There is a wide market for all cat art, especially cat plates. Once it is known that you can reproduce a true likeness of a cherished feline friend that holds a special place in a person's heart, you will become a very sought-after artist. One of the best ways to follow this pursuit is to join a cat club and participate in cat shows: exhibit your work and you will be accepted as a cat virtuoso.

Consequently you may find yourself approached to paint pretty Puss in oil paint. If you are a natural cat artist and would like to work on a larger scale, do not hesitate to venture into this medium, and with your consummate skill as a porcelain artist you will find that oil painting will appear simple. Thin, transparent layers of pure oil paint are added, one on top

of the other, allowing each layer to dry. This method of painting was used by the Old Masters and is known as the Venetian technique. As each tint is applied the depth and luminosity shows through, creating a rich depth of paint in much the same manner as in ceramic art, firing and sanding as we go. For pleasure or profit painting, cats could prove a happy enterprise. The following guidelines may be used for all mediums.

Preparation for painting cats

You will need good reference photographs, not just one or two but many, and today it is accepted that photography has a place in art. You can still make on-the-spot sketches if you are able and wish to do this; however, as cats are very difficult subjects to capture in good poses, the best idea is to photograph them at all angles. Create close-ups of their fur patterns, eyes, tails, whiskers, how they stand, and build up your reference file with notes and observations. It is how you interpret your cat photos that is the main concern. Try to make them lifelike and not too formal; they are fluffy and soft, so show this.

As with all portraits the essence of the subject has to be captured. We know cats are full of character, and owners are happy to pass on this knowledge regarding their

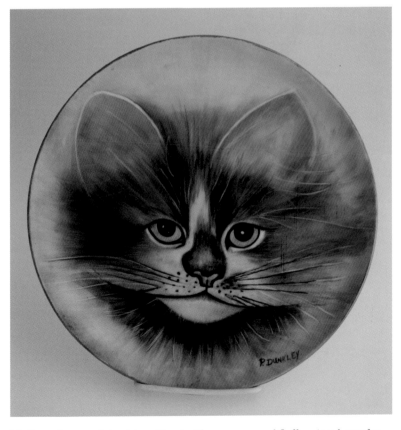

Medium-size porcelain plate with cat with green eyes and fluffy painted grey fur.

127

pet. A particular cat's idiosyncrasies can be very useful in your interpretation. Wide-eyed or sleepy, playful or tranquil, fat or thin – it is surprising how these perceptions can assist you to achieve good results. A satisfied client will soon spread the word as to your ability.

Painting fur

You must paint fur hairs in the direction in which they grow: that is, from the base to the tip. Cats are very specific animals with distinctive markings, which have to be followed. They do not have ruffled fur; they are sleek and svelte. Observe closely which way the fur grows on the cat's nose, on the inside of its ears and around the mouth. If you follow the same direction of body fur and tail with that of your brush, it will make your cat look authentic.

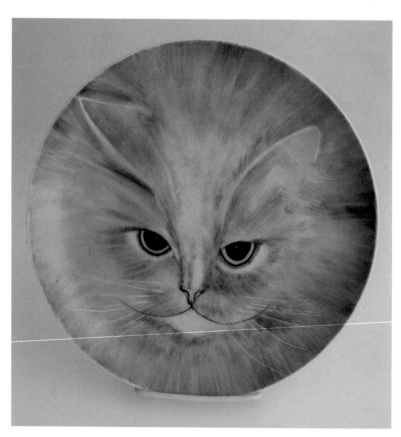

Medium-size porcelain plate with softly painted yellow cat.

Cats' eyes

As the eyes are the most important part of the cat, you must get the correct shape and colour from the study you are using. Establish them first: check for eyelashes – long or short – and count the amount of 'whisker' hairs above the eye. Cats' eyes are all different, with pupils round or elongated, and the expression they show is always telling. Capture it well!

Whiskers

Whiskers are very important and put the finishing touch to a painting. There are four layers of whiskers on each side of the mouth, varying in length and angles. Make very sure that you paint them correctly, as they are crucial to your cat's personality. In porcelain painting we have to pull the whisker out of the paint while wet; in watercolour and oil we add them at the very end with a fine long-haired brush.

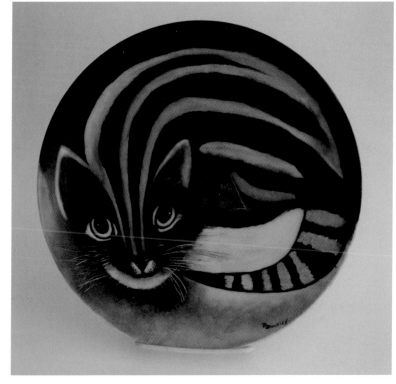

Medium-size porcelain plate with distinctive black and yellow striped cat design with green background.

Facial markings

If the cat in your photograph has distinct facial markings, you will see that they are identical from one side of the cat's face to the other and it is important to always match these features, otherwise the painting does not look correct. A tabby cat with dark markings is wonderful to paint, and much admired.

Kittens

Kittens make superb subjects, with pretty eyes and playful ways. Try to photograph them in all stages of growth, and with the mother cat if possible.

Breeds of cat

There are many breeds of cat, from Abyssinian, Burmese, Chinchilla, European Shorthair, Japanese Bobtail, Maine Coon, Persian and Siamese to

Tabby Longhair. The variety is endless and growing all the time. Familiarize yourself with the breed of cat you are painting, and get the correct markings.

Dog-themed art

Man's best friend is enjoying huge popularity in auction houses around the world, with record sales and stupendous prices being paid for paintings depicting dogs in each and every form of art. Oil, watercolour, pastel, porcelain, pottery and bronze, canine art is on the way up and escalating all the time. Spirited bidding takes place in sales rooms and telephone bids flow from all corners of the globe. Recently a 6-inch by 8-inch oil painting by Gerrit Dou called *A Sleeping Dog beside a Terracotta Jug, a Basket, a Pile of Kindling Wood*, dated 1650, sold for five million dollars!

It appears that everyone wants to own a dog painting, and preferably by a well-known artist who has specialized in animal art, and more particularly dogs. At the turn of the nineteenth century it was extremely popular to paint sentimental pictures encompassing animals and children. Arthur Wardle was an English painter widely known for this genre, painting every breed of pure-bred dog that existed in his day in domestic scenes; with little formal training but profound natural talent, he became proficient in oils, watercolours and pastels. Among his assignments was one of 250 cigarette cards, miniature works of art 1.5 inches by 2.75 inches. These were given away in packets of cigarettes by prominent tobacco companies, and have now become extremely collectable.

John Emms, another such artist, was famous for his *New Forest Hounds*, a painting commissioned by the Master of the New Forest Hounds of Lyndhurst. A true work of art skilfully composed and executed, it features thirteen hounds and one terrier gathered together in various poses, with the original key name and birth dates of each dog. This famed and now historical 1898 animal painting, which recently sold in New York for $850,000, will no doubt increase in value with the advent of changed fox-hunting laws.

Contemporary artist James Yates Carrington's work *The Orphans*, an

endearing scene of a forlorn bulldog and terrier locked up behind bars, eclipsed his own previous auction record price, selling for $50,000.

Marguerite Kirmse was a British artist who emigrated to America and established herself as a canine master painter of note. She worked in pencil, pastel and oil, executed a series of bronzes besides illustrating dog books, and was most renowned for her etchings of Scottish Terriers, which Wedgwood produced as decorative plates – a versatile and talented lady whose work now appears in the collection of the American Kennel Club.

Cassius Marcellus Coolidge is recognized for his paintings of dogs in human situations. His cigar-smoking, poker-playing dogs were printed by the thousand as advertising posters and used as give-aways by cigar companies. He also depicted dogs sitting on commuter trains and in ballparks for the same advertising purpose.

Around this time Lillian Cheviot, another competent British dog artist, was producing delightful works of Sealyham Terriers in Highland landscapes – exquisite art, with close-up endearing-faced animals posing in beautiful purple and white heather, with misty mountain scenes swirling around in the background.

Whatever the composition, it would seem that there are not enough dog paintings to satisfy the growing market.

Queen Victoria started the vogue for animal portraits, being a great lover of dogs and dog paintings, and she is credited with moving dog art into a new direction, surrounding herself with visual reminders of her favourite pets painted by notable artists of the day. In her kennels at Windsor she would keep up to seventy dogs at a time, and was interested in all of them. It was said that animals provided her with more solace and comfort than the humans in her court. This is often the case in society today.

Victoria's preferred artists were Sir Edwin Landseer, Gourlay Steele, Charles Burton Barber, Arthur John Elsley and Maud Earl. Maud was one of only a handful of female Victorian artists famous in this genre, with a wide royal patronage. At the onset of World War I she moved to America and set up a very successful studio in New York.

These canine masters were commissioned regularly to depict terriers and sporting animals at work, with enormous St Bernards and stately Collies posed alongside pretty children in a romantic fashion. Family scenes with Queen Victoria's own special pets and other animals were used in a picturesque style. It was an era enhancing the virtues of dogs and happy domesticity.

It is the artists' ability to capture and portray the feelings and expressions of man's best friend that has greatly contributed to the success of dog-themed art.

The long-standing friendship of fifteen thousand years between man and dog has become an important part of our history. Descended from the grey wolf, there are now over four hundred breeds of dogs around the globe, and the modern dog has gained the reputation of understanding humans and what it is that we require of him. Dogs provide loyalty, unconditional love, companionship and laughter, supplying us with all of these pleasures plus canine assistance in cases of physical disabilities. Pushing wheelchairs, turning on lights, showing the way for the blind, sniffing out drugs and flying into space, dogs have truly earned their place in art history.

Such is the case for Greyfriars Bobby, a Skye Terrier who refused to leave his master's grave even in the worst of weather conditions in Edinburgh. For fourteen years this faithful dog kept watch and guard over the kirkyard where John Gray's body was buried, only leaving the grave to take his midday meal at the local coffee-house, which he had frequented with his now dead master. Bobby became a celebrity because of his fidelity, and crowds would gather to see this little dog sitting by his master's grave.

With Bobby's passing a statue was erected opposite Greyfriars Kirkyard. Scotland's capital city will always remember its most famous and faithful dog. Bobby's headstone reads: 'Greyfriars Bobby – died 14th January 1872. Let his loyalty and devotion be a lesson to us all.'

We have come a long way since Queen Victoria's days, with pets in playful settings. The quest for the future is a robot dog, and by the year 2012 scientists hope to perfect the K9 Aibo dog – 'a must-have on the Christmas lists'. Rin Tin Tin, Lassie, Nana, Toto and Nipper of HMV fame will be old hat, and K9 will

be able to tell us what to eat and when we have had enough!

Nothing will ever take the place of man's best friend, and if you would like to paint dogs it can be extremely satisfying. Heads and profiles make wonderful subjects. A Scottish Terrier like Bobby, Welsh Corgi, Cocker Spaniel, British Bulldog – there are many breeds from which to choose.

The artist Maud Earl would pose her dog on a portable stool on castors, then move it around to draw the animal at all angles. If direct sketching is not for you, use your camera.

You will find that dog plates are very popular and widely collected. Tiles are useful to paint a panel of dogs in action, while medallions are perfect for miniature art. A black and white pen-and-oil drawing is very effective and can be achieved in one firing.

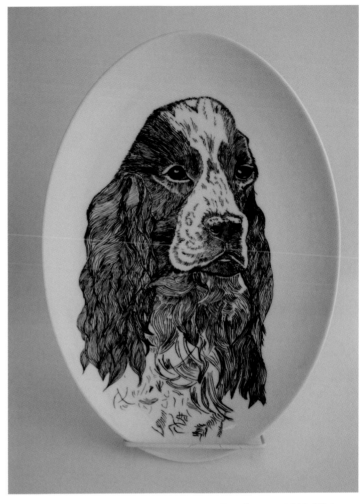

Black and white pen oval plate with portrait of Cocker Spaniel 'Goldie'- blue ribbon.

Once again, you may find requests for Fido to be painted in another medium, watercolour or oil as well as your porcelain art. If you have taken up this challenge, being multi-talented and able to swing from one style to another will benefit your art in the long run. The following advice can be used for all methods, the only difference being that unlike porcelain and watercolour painting, where you build up the colour to reach the final depth,

with oil painting you do the reverse, and work from your heavy dark colours to lighten and tone down to reach the final result.

Do not be too ambitious with your first dog study. Choose a subject with bright open eyes, short hair and upright ears, such as a Corgi or a Jack Russell, because both of these breeds make excellent models. Paint the animal close up so that you can see it clearly and learn from your first effort. If you are unable to find the necessary type of dog for your purpose, advertise for the breed you want and explain your dog art. Pampered pooches are there for the asking, with owners waiting for Bill the Bulldog, Maisie the Poodle or Flash the Greyhound to be immortalized.

Have ready for use your palette, brushes, paints, oils and all the necessary materials, including your sketch or photograph.

Guidelines for painting dogs

- As discussed, you will need a portfolio of sketches or photographs of your subject. Even if you are painting your own dog, the chances of it posing for any length of time are highly unlikely, so quick drawings and lots of snaps of the animal in various poses are the best solution.
- With your outline of the dog established on your porcelain, paint the eyes first. Showing the shape and size of the pupil is essential, so put in your highlight – this is very important, as it indicates where and how the dog is looking. Do as much eye-work as you possibly can, making sure you have the correct colour and distance between the eyes, and also that they are level.
- Work down and paint in the nose, once again looking for highlights, as every breed of dog has a different-shaped nose and characteristics. Some are pointed, snub or flat, but they all have nostrils with distinct form. Keep moving down, and draw the outline of the mouth.
- The ears are next and the shape depends on breed, being long and floppy, pointed or level. Are they pricked up and paying attention? Indicate the attitude by good varied brushwork, dabbing with your silk pad to keep the paint in place.

- Dog hair grows in different directions on various parts of the animal. Try to imitate this in the way you apply the paint, making it smooth or ruffled according to how it appears. This is one occasion you should be using your stippler brush to obtain an effect of short hair around the animal's features.

- If you are doing a head study, put as much detail in as you can for your first firing, making very sure that the eyes, nose and ears are correct for your particular model. Dogs are appealing subjects, so try to capture their beguiling look at the onset, perhaps in the way they tilt their head or the particular look in their eye. Each animal has its own individuality, so learn the appeal factor and show it in your painting. Strengthen the colour and stature of the animal with each firing.

- When depicting the entire animal you will have to study its proportions and characteristics: whether it has long or short legs, what type of body, fat or thin. Muscle structure differs when the dog is sitting or standing, and paws vary in size according to age and breed. Puppies usually have a floppy look and can be roly-poly, with large expressive eyes. Emphasize these endearing features to full advantage, as puppies are a popular theme in dog art.

- Tails are another important feature. They can be short and stubby, thin and pointed, long-haired and fluffy, standing upright or dropped down. Tails are a sign of how the dog feels, whether happy or sad, attentive or sleepy. It is the mood messenger and you must pay attention to the way it looks. When painting the tail, make sure you incorporate it into the body as an extension of the spine, and not something tacked on to the end of the dog.

- The Victorian artists were masters at giving a sense of scale, and you must show the viewer the size of the dog by including something to compare it with. Give the painting a sense of perspective, whether it be a child holding the lead or Fido playing with a shoe or standing in a landscape with a mountain in the background. Show the size and breed of the dog in an interesting pose. Pet dogs sit indoors on satin cushions and play

with their 'toys' or perch on their favourite chair, while outdoor dogs look good in a farmyard setting with a gate or fence – or perhaps, if a puppy, chasing a butterfly.

- Give the composition a true feel of ambience, so the viewer recognizes the type of dog just by the setting – unless, of course, you intend to anthropomorphize your subject and have him sitting at the table playing a board game or working at the computer, in which case you can really let your imagination fly.

The royal touch

Queen Victoria led the way for dog art to flourish and Her Majesty the Queen continues the support of canine capers. Patron of the Kennel Club and owner of Welsh Corgis, she is a keen dog breeder, crossing a Welsh Pembroke Corgi with a miniature Long-haired Dachshund and subsequently christening the type 'dorgi'. Mixed-breed dogs are all the rage and proving very popular, with inter-breed mixes including Labrador and Poodle (Labradoodle), Schnauzer and Poodle (Schnoodle), Cocker Spaniel and Poodle (Cockapoo) and Yorkshire Terrier and Poodle (Yorkipoo). There is no lack of variety for you to paint in the dog world.

Dog shows abound during the course of a year, culminating in the world-famous Crufts, with its Best in Show competition. This is an annual international championship, organized and hosted by the Kennel Club of the UK and held at the Birmingham National Exhibition Centre. It is the largest dog show in the world and lasts for four days. Here you will see every assortment of pure-breed animal, with a registry dating back to 1873.

If you wish to specialize in canine art, you will do well to follow these fascinating spectacles, as it is there that you will find beautiful specimens and a possible interested client for your particular interpretation of their favourite pet. Dog-lovers are renowned for wanting lasting mementos of their beloved animals. What could be more appealing than a beautiful hand-painted piece of porcelain, whether it is a pure-breed dog or a hybrid variety being depicted? An elegantly shaped vase with Scottish terriers in a rotating

Highland landscape … the stately head of an Afghan Saluki on a plate, with a deep rim of rich matt gold enhancing the model … a black and white pen drawing of a Cocker Spaniel on a medallion mounted in a gold frame … whatever breed of dog you choose to paint, make sure you do so with feeling and with the integrity they merit. Man's best friend is just that and deserves to be represented in the highest form of art possible. Porcelain painting is renowned as a fine art, so give your work the royal touch, with elegance and polish, and present it in a glorious velvet box tied with silk ribbon.

CHAPTER 12

BIRDS

The charm and beauty of the bird has long been a cause of fascination to society. Exotic birds with brilliant plumage and rare appearance, or even the more familiar wild birds that frequent our garden and are heralds of the seasons, these feathered wonders captivate us with their independent disposition and cheerful attitude to life as they gather food and prepare nests for their young.

Little wonder those yesteryear artists were eager to reproduce these colourful spectacles on flawless porcelain, in delicate tints of pink, blue, lemon and eau de nil. They also painted them in watercolour, illustrating them in flight, on scrolls of heavy parchment or, in the 1700s, daintily perched on hand-painted embossed paper in *basso relievo* style for their own artistic pleasure or posterity. Birds are wonderful subjects and have excited humankind from earliest times. Soaring through the air, travelling long and short distances with masterly precision, can only stimulate the mind with awe and admiration at the innate ability of birds.

As the swallow returns from Africa to our shores in April, its looked-for visits to familiar haunts are like an old friend. The nightingale, the 'Queen of Song', fills a still June night with melody that, once heard, is never forgotten. These simple pleasures of sight and sound lift the human spirit, making birds a source of delight.

An English summer without a swallow would be as unheard of as a winter scene without Robin Redbreast. These two admired birds constantly

appear in art, both for their colour and beauty of form and for their traditional meaning of spring and winter, as does the Bluebird of Happiness, with its fine long-tipped wings, and the puffed-up chest of the red robin. Both bright and easily recognized beauties adorn many a piece of fine personalized porcelain, Christmas cards, jewellery and enamelled objects d'art, besides other forms of bird art.

George Edwards is known and recognized as the 'father of British ornithology'; he was a pioneering writer and illustrator of birds and natural history. Combined with this career, Edwards was also the Beadle of the Royal College of Physicians for twenty-seven years. This unusual combination opened doors, enabling him access to sketch the menageries of the aristocrats while carrying out his other College duties. His most significant patron was Sir Hans Sloane, the founder of the British Museum, President of the Royal Society and the Royal College of Physicians, who encouraged and helped Edwards to publish his drawings.

Born in rural Essex in 1694, Edwards spent his whole life pursuing his artistic passion. A bachelor and lone traveller, he sketched on his journeys through Europe, producing much sought-after drawings. His books, *A Natural History of Birds* and *Gleanings of Natural History*, published in 1751 and 1758, vividly describe and illustrate birds, animals and insects from around the world, and brought him great acclaim. Up until then little was known about the subject, and they opened wide the door to the ever-curious public. He ultimately became more distinguished than the presidents he served.

In his footsteps came Mark Catesby, who created the first American ornithology, followed by fellow-citizen Charles Audubon's *Birds of America*. British-born John Gould, together with his wife Elizabeth, then produced *A Century of Birds Hitherto Unfigured* from the Himalayan Mountains. Next came Gould's *Birds of Australia*, acknowledged as the greatest of his major works and depicting 681 bird varieties. These illuminating volumes, along with many others, were used as source material for decorating works of art and became the 'bird bibles' of the day.

Recently there have been many well-known artists who have devoted their lives to the painting of birds and wildlife – Vernon Ward, Charles Tunnicliffe and Winifred Austen, to name just a few. The most prominent of this period, however, would be Sir Peter Scott, whose father was Scott of the Antarctic of exploration fame; Sir Peter was a naturalist and conservationist who was also an artist and author and the founder of the Wildlife and Wetlands Trust. These artists interpreted birds on the wing in stunning settings – spectacular sunsets with bird formations, or natural scenes of swans, ducks and ducklings in picturesque surroundings.

In ceramic art, birds have been fashionable since the 1800s. With the availability of more literature on the subject, companies produced exquisite vases with fancy birds in all types of styles, and freelance porcelain painters as well as factory artists were turning to birds as a main theme.

In the 1900s Charles Baldwyn, a Royal Worcester artist, excelled in bird painting and made it his own, fashioning an unequalled reputation in this genre. He was born in Worcester during the middle 1800s, when one can easily imagine that the surrounding countryside of the Malvern Hills would be full of twittering bird-life complementing the sounds of Elgar's music. For a bird-lover such as Baldwyn, sketching nature was part of his artistic endeavours, and birds such as the wood-lark, chaffinch, linnet and tawny owl would later appear on his porcelain in the authentic shades of his live models. However, it was the painting of swans that firmed his reputation and ultimately became his signature work.

Companies such as Coalport, Spode, Worcester, French Limoges and American Limoges, besides other independent manufacturers, were all producing bird art. Lifelike mallard ducks floated on golden water in apricot sunsets painted on ribbon plates, and small dainty songbirds appeared on delicate porcelain shapes embellished with pink roses. Game birds, such as the turquoise-throated pheasant, with long plumed tails painted in autumn shades, adorned plaques and vases. It was extremely decorative work and in keeping with the subject.

In the mid-1930s complete sets of plates taken from Audubon's *Birds of*

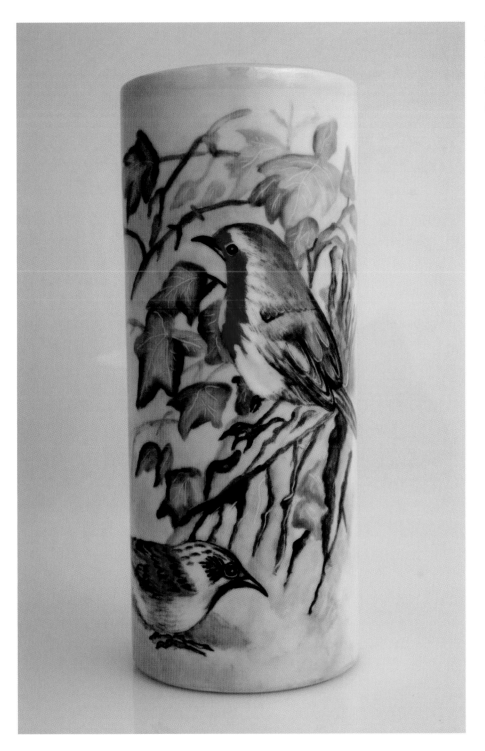

Cylinder porcelain
vase decorated with
naturalistic bird
subjects of robin
and sparrow with
mother of pearl rim.

Back of cylinder vase decorated with bird subject of thrush in snow setting. With mother of pearl rim.

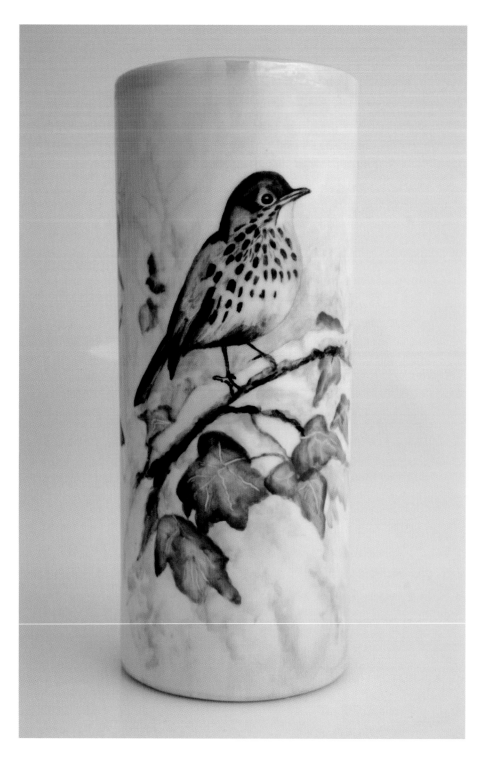

America were commissioned. The ruby-throated hummingbird and barn swallow, along with twenty-two other specific birds, were depicted with a border grounded in chrome green and heavy gold 'honey gilding' hand-painted by Worcester artists. Each plate required eleven firings.

In the 1940s Spode produced many transfer-printed Audubon birds, which were then hand-painted by the artists. Tea and coffee sets as well as plates and dishes were adorned with fine-feathered friends, and a celadon blue rim was added, while others carried a green ground. In the 1960s Coalport artists produced a limited edition of British bird plates with a 22-carat gold border, in a traditional style with a leaf or flower setting. The celebration of bird painting thrived, and still does.

Not only were birds enthused over and waxed lyrical about, but also their nests were brought into vogue. A whole genre of bird-nest paintings was much sought after in the Victorian era: birds' nests in still-life settings of mossy green banks, amid blossoms of primrose and violets, and spring flowers, speckled eggs and the occasional fairy sitting in a carefully made and highly ornate bird's nest. One of the best-known paintings of this type was *Fairies in a Bird's Nest* by John Anster Fitzgerald, c. 1860.

There are two distinct types of bird painting, the first being realistic lifelike copies of the natural model in a formal setting. Alternatively there is a more flamboyant style of painting – very colourful, but not concentrating on the distinct plumage.

It would seem that true bird enthusiasts want to see the markings and feathers well defined; this takes time and dedication but is well worth the effort when the final study is completed. However, painting your birds in a loose impressionistic fashion, merely showing form and colour and the general appearance of the study, is very fetching. This latter method works well within a painting that incorporates other features, such as flowers or a nest, a duck flapping its wings, a farmyard chicken, birds in action and the like.

Now that you have mastered the general use of mineral oxide paint, there is no reason why you should not attempt both methods. Bear in mind that the

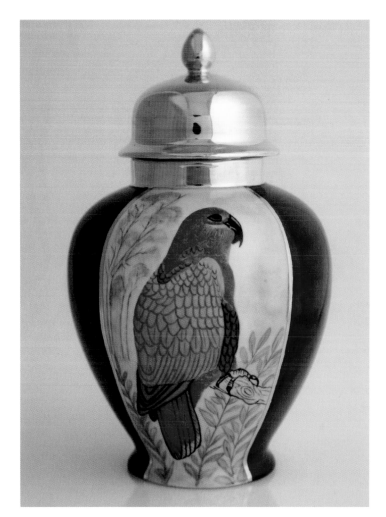

Left and opposite: A superb handed pair of German porcelain pointed lidded jars, hand gilded with best liquid bright gold and ruby red lustre panels, edged with liquid bright gold. Reserves finely painted with matching exotic red and blue feathered birds.

realistic painting will require a firmer mixture of paint and more firings, while the other technique requires washes of colour and a softer approach.

The end product is what really counts, and your choice of porcelain on which to decorate is an essential part of this. So try to visualize your design on the shape that you have chosen. A stately formal bird looks well on a plate with a pretty grounded border. Choose a colour to accentuate the bird, and finish the whole piece with a heavy gold rim. A tall straight cylinder vase is perfect for a well-defined owl, to emphasize the size of the study, while fluffy informal birds in joyous colourful backgrounds look well on ribbon plates, ornate shapes with scalloped edges, fan-shaped plates, bon-bon dishes – in other words, fancy designed porcelain – all these considerations add to the final beauty of the piece. Every ceramic artist has his or her own style, and you must develop this so that your work is recognized by a particular attribute in the same way as past artists are now sought after for that very reason.

Guidelines for painting birds

- You will need the full palette of colours, brushes, silk pads and the necessary mediums that you always use, and a good natural study of your subject to work from.

- Make a perfect copy from this and transfer to your piece of porcelain in the usual fashion. If you are painting in the impression-istic style and do not require specific details, draw your birds directly on to the porcelain with your chinagraph pencil; you will still have to make a good composition, so indicate the position of the birds satisfac-torily within the whole.

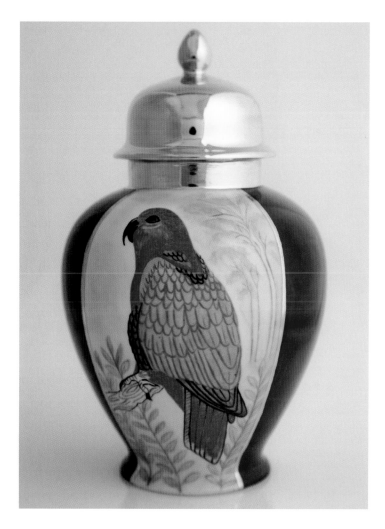

- Apply the local colour in the required strength for a first coat. Check your study and see if there are to be any white highlights; if so, pull them out now with your brush or rubber pencil before firing.

- Once again the principal feature is the bird's eye and the expression it has within it. Is it looking up or down, directly at you, or at another bird or an insect? This is your first consideration before you consign it to the kiln. You do not want a cross-eyed bird, so make sure that you are happy with your depiction.

This page and opposite: Matching green and black exotic bird in pale blue leafy background.

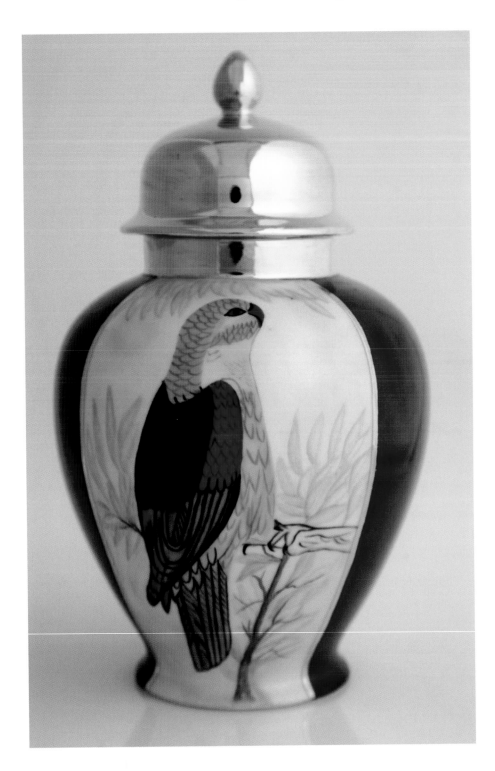

- The bird's feet and bill must be placed correctly, especially if you are painting a lifelike study. There is more leeway in an informal approach but they still have to look correct.
- The thickness of the bird's legs is most important and stands out if not accurate.

At this point in the procedure, once you have a good covering of paint on the bird, in the right colours and position, you can give it a high fire.

Second firing

From here on, the method you are using will depend on your type of painting. For the softer work it is a matter of strength-ening the colour and the outline, but not too strongly – you do not want to silhouette your bird.

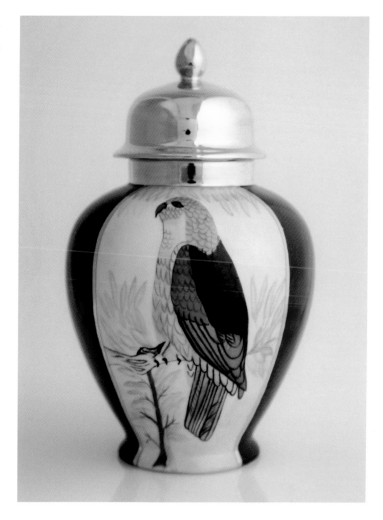

- Blend the colours indicating the shape of the bird as you go. Humming-birds, swallows, wrens, all have distinctive points and you can show this to advantage without making it look too stiff. You should be able to do your fancy plate with flowers and birds in three firings.
- The lifelike bird. Now that you have your first coat of true colours established and fired, it will be possible for you to work on the plumage,

copying from your study. This will take time and perseverance with firings as you go.

The painting of birds is intricate but well worth the effort. These sparkling jewels that fill our skies, together with butterflies, dragonflies and other such lustrous insects, are all there for our decorative art and make wonderful subjects.

Make sure you sign your piece with a flourish: being a ceramic artist is something to be proud of. Beautifying the world with works of art is to be commended and enjoyed by all enthusiasts.

CHAPTER 13

BLUE AND WHITE PORCELAIN

The magic of blue and white porcelain is difficult to explain; nonetheless, the appeal it carries is forceful and lasting. For some enthusiasts it conjures up cosy teashops on holiday locations, devouring fat scones, cream and jam served on deep cobalt blue and pristine white plates, with a teapot, sugar bowl and jug to match – an association of good times spent in joyful surroundings bringing happy memories. For other devotees it might be the remembrance of a visit to a certain museum specializing in this field, such as the Spode Museum Trust with the ever popular Blue Room Collection, Worcester Porcelain Museum (formerly known as the Dyson Perrins Museum), the Salting display at Fenton House in Hampstead, or a fondly remembered romantic moment when you were given a piece of blue and white Meissen fine porcelain by a special friend for a keepsake.

Whatever the occasion and wherever the event took place, blue and white porcelain has long been a favourite for an old-fashioned and friendly feel. Most homes hold at least one piece of this desirable ware, such as a commemorative plate sporting a cat or a dog, a clog with a recognizable motif, jugs, dishes – all manner of sizes and shapes of porcelain in decorative blue and white that has been collected over the years. Or it could be Grandmother's Wedgwood bowl with a transfer-printed scene of a couple in a hansom cab and days gone by, passed down from one generation to another. Then there

are those who admire this particular genre so much that nothing is more satisfying to them than a complete kitchen or bathroom tiled in blue and white: for them, this is a definite requisite for a united family home.

History is full of fantastic stories surrounding blue and white porcelain. None is more bizarre than the tale of Augustus the Strong, Elector of Saxony, and the King of Poland reaching an agreement with the kingdom of Prussia in 1717 to exchange a regiment of six hundred imperial soldiers, true and strong, for a group of Chinese Kangxi porcelain vases, which are still on display in the Dresden Museum in Germany and known as the 'soldier vases'.

Blenheim Palace, home of the Dukes of Marlborough and birthplace of Winston Churchill, has prominent displays of blue and white porcelain acquired in the early 1880s, as do other stately homes run by the National Trust.

Tales of intrigue abound over artists and dealers procuring precious and most desirable pieces of blue and white porcelain for outrageous prices. Serious buyers, who were keen to be the first to acquire a collection fit for royalty, pursued the famous Victorian ceramic dealer Mr Murray Marks, who was renowned for his expertise. There were beautiful long-necked vases in sets of three or five, and large lidded ginger jars exquisitely decorated with the prunus blossom – or the winter blooming plum tree from the early 1700s. Unusual-shaped plates finely painted with graceful elongated Chinese ladies, dressed in a traditional manner and known as 'Lange Lijsen', were part of an exciting and different period for those who could afford to purchase such wonderful Oriental treasures.

It was not long before famous artists of the mid-Victorian era, such as James McNeill Whistler, were including the depiction of blue and white porcelain within their elegant works of art. The painting by Whistler called *Purple and Rose: The Lange Lijsen…* shows eight pieces of blue and white ware carefully composed within a room and a model dressed in a flamboyant Asian style holding a vase on her lap, with a paint brush in her hand. Whistler was an avid collector himself, and it is said that his enthusiasm for Oriental porcelain helped trigger the British public to catch the fever. Porcelain mania

was Whistler's contribution to the Aesthetic movement known as 'Art for Art's Sake'.

Picture the scene: Dante Gabriel Rossetti, Aubrey Beardsley, Edward Burne-Jones, William Morris – an imposing list of artistic personalities that goes on and on. These artists were suddenly discovering the beauty of hand-painted blue and white porcelain and became totally absorbed in the medium. This avant-garde movement considered that art did not require any teaching purpose or practical use: it need only be ornamental.

Such was Whistler's zeal with the painting of blue and white that he agreed to illustrate catalogues and design patterns using pen and ink and watercolour wash drawings, excellent practice for monotone work. This still life art of his was exhibited alongside Chinese porcelains that were on sale in Murray Marks' London premises.

During this time, 1870–80, the race was also on among American tycoons to amass great collections of precious blue and white porcelain. John Pierpont Morgan is reputed to have had the finest collection ever brought together, while Henry Clay Frick and John D. Rockefeller Jr, both passionate pioneer collectors, eagerly joined the chase. Much of this exquisite ware can now be found in the Metropolitan Museum of New York and other well-known American museums, where one and all can study it to advantage. The Freer Gallery of Art in Washington DC houses the famous and important 'Peacock Room' in its entirety. This harmony in blue and gold, with flowing peacock feathers of cobalt blue and the painting *The Princess from the Land of Porcelain*, once again shows Whistler's love of the colour blue and the way he combined it with one contrast of gold, much in the fashion of ceramic art. Whistler contrived the room's interior to enhance a collection of blue and white porcelain from the Qing dynasty (1644–1911) which at the time was in the possession of his patron, Frederick R. Leyland; some of it is still on display.

Perfecting and producing the first blue and white ware was commenced in China in the early fourteenth century. The location of Jingdezhen is recognized as the porcelain capital of China, and the production of blue and white wares continues to this day. During the reign of the Kangxi

emperor (1662–1722, Qing dynasty) the porcelain made at Jingdezhen reached the height of its technical excellence. The blue, from native cobalt ores, was very rich and jewel-like, the painting bold and freely done with control and detail and the designs Chinese in taste, with symbolic meanings. The language of flowers is well known: lotus blossom is rebirth; the tree peony is a symbol of spring, wealth and beautiful women; the chrysanthemum is for autumn, and the plum signifies winter and old age. These are now the pieces most sought after, as traditional designs have changed with the influence of other cultures.

By the beginning of the seventeenth century, porcelain was being manufactured by most European companies, and all of the factories were influenced by Chinese and Oriental designs. The first to establish blue and white ware was Meissen of Germany in 1707, with an early blue onion pattern. Hand-painted and transfer-printed wares in blue and white were being carried out at Worcester and other early English factories in a style known as Chinoiserie during the latter period of the 1700s, while it was in 1784 that Spode perfected the process of blue underglaze printing. Others, such as Worcester, Derby, Lowestoft, Caughley, Bow, Coalport, Nantgarw, Coalbrookdale, Minton, Royal Doulton and Wedgwood, were quick to follow. Paintings in the Chinese manner, with pavilions and boats in watery landscapes, floral designs, fancy birds and fish, all appeared in blue and white, while Blue Italian, Tower Blue and Willow, all original patterns from the period 1790–1820, are still in production at Spode today.

The popularity of blue and white porcelain seems never to fade. In the Netherlands at Royal Delft, a massive undertaking took place to reproduce Rembrandt van Rijn's *The Night Watch*. This was carried out by two of their master ceramic artists, who together painted 480 tiles in one colour blue to complete the work, now proudly on display at Delft.

At Royal Copenhagen in Denmark, the birth of blue patterns was in 1775. The design known as Blue Fluted has been a favourite for more than two hundred years, followed by Blue Flower, a contemporary European style of naturalistic flowers. Christmas plates and – a later introduction – Mother's

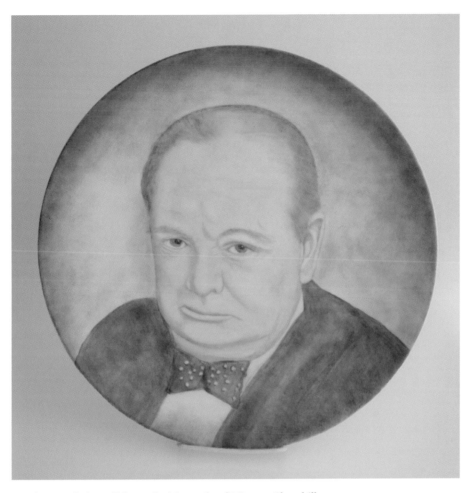

Hand-painted plate of blue and white study of Winston Churchill.

Day plates still flourish, with a variety of blue shades.

In America the much-favoured reproduction of blue and white porcelain for the table is designed on the Canton ware patterns, named after the great Chinese trading port; fashionable tables in the early American Republic were set with Canton, and the practice is still in vogue today.

It is possible to paint any subject in blue and white – portraits, flowers, scenic landscapes, birds, animals – as is proved by the continuous flow which appears on the market. Commissioned and individual pieces of hand-painted porcelain have a special appeal, and client request for decorative tiles,

anniversary plates or dinner sets are not unlikely. This is also an opportunity for you to create a totally new design to work in your pen and oil.

Guidelines for painting blue and white

- There are many shades of blue available other than cobalt – delphinium, powder blue, Sèvres blue, they all vary in tone and are each exquisite when worked alone.
- Blue is notorious for being grainy, so take the time to grind the paint and sieve through a silk stocking, to eliminate this problem.
- Make sure that you mix sufficient blue paint to complete your design or pattern with the one batch you have mixed. Tones vary from one mixture to the next – you do not want that to happen.
- When you have a coloured photograph and wish to transpose it to a blue and white painting, make a photocopy of it in black and white. In that way you can follow the light and dark shades with your blue. This is a very good technique when doing a portrait.
- For pen work use a quick-drying pen oil with pure gum turpentine, as previously explained. The mixture has to be free flowing so that you can glide your strokes over the glaze. Pen plates are fired at 815°C.
- If you are going to fill in your design with an alternative shade of blue, use copaiba oil and pure gum turpentine and make a mixture that is easy to brush in. You then dab with your silk pad to remove any signs of brush strokes, leaving an even look. Fire again at 815°C.
- Repeat the procedure until you have the desired final colour.
- When you are painting flowers or a set subject and you need to shade the design, it is better to work with a slightly heavier mixture, of toothpaste consistency. Copaiba oil and pure gum turpentine is popular and easy to manage.

Classic blue and white porcelain is hard to overlook and has a true following. Whether you decide to fashion an Oriental-styled piece or a bright new

twentieth-century pattern, make sure that you fire the work well and experiment with all the variety of blue shades that are available. In that way you will discover the one that is suitable for your style of work. There is a great deal to remember when decorating porcelain, but always start at the top of the plate, vase, bowl and work down. Using this procedure you are less likely to smudge your wet paint and will get good final results. Who knows, you might even become passionate about blue and white porcelain in the same way as Whistler. This highly respected American artist considered the paintings in cobalt blue on the beautifully shaped vases, bowls and plates 'the finest specimens of Art', elevating this fascinating medium of decorating fine objects d'art above the commonplace.

CHAPTER 14

TECHNIQUES OF FRUIT PAINTING

The wonderful part about painting fruit is that ultimately you can eat your model, so buy the best you can afford with interesting colours and much flavour to enjoy. Fruit comes in all shapes and sizes so choose the most alluring to the eye when you set up your still life, as some fruits appear more ornamental than others when illustrated in painting.

In the year 1760 Jean-Baptiste Simeon Chardin chose to paint *The Sliced Melon*. The skin of the fruit is the colour of linen, the flesh a subtle pink, as the uneaten slice balances above a dish of velvety peaches, three plums and two pears along with two well-shaped bottles and an interesting jug, as they sit decorously on an old wooden table. This Parisian artist is famous for his subtle colours and stillness of composition. *Basket of Wild Strawberries* shows a pyramid of the fruit, one crystal glass of water with rosy reflections, two white carnations, one peach and two cherries – a glorious painting which speaks volumes without crowding the canvas. Simple everyday objects that Chardin used to create his masterpieces appear lifelike, painted in their true colours, and blend together as a whole. Fruit 'feasts' on completion of these works give new meaning to the expression 'food for thought'. Madam Chardin no doubt would have garnished the strawberries with cream and a little sugar, sharing them equally as together the artist and his wife ate their banquet while studying the completed canvas.

The painting of fruit played a significant part in Chardin's oeuvre, and more so towards the end of his career. He instinctively knew where to place his particular objects to display their interconnection, and which type of fruit to feature for the play of highlights and texture. The work of art was thoughtfully put together, shapes and spaces all planned to perfection.

The artist Paul Cézanne, on the other hand, interpreted fruit painting in a completely opposite manner. A cloth thrown loosely over the table, draped high and low, would have a selection of fruit scattered in an almost abstract fashion. Brightly coloured apples of red, green and yellow tumble across the foreground and almost topple off the table, and oranges and lemons fight for supremacy in their glowing brilliance, together with a chunky piece of pottery. The viewer is led to believe the fruit is alive and on the move, a domino effect if an apple falls, a still life only in name. The painting of fruit had arrived and was deemed special, as each artist illustrated compositions in their own particular style.

During the eighteenth century still life and particularly the painting of fruit became extremely popular. George Lance, a leading British artist, devoted himself to this art form, modelling his work on that of the Dutch and Flemish painters of the past. Unlike Chardin with his minimalist settings, these presentations show masses of fruit beautifully captured and full of glowing colour, correctly represented with no other objects to distract. *The Autumn Gift*, painted in 1834, has black, green and coral grapes, russet apples, apricots, peaches, plums and greengages, luscious-looking fruit that was known to be the produce of grand houses. This painting now hangs in the Tate Gallery for all to see.

William Henry Hunt was another artist renowned for his fruit subjects, particularly his special techniques which enabled him to obtain the 'bloom' on peaches, plums and grapes. He and George Lance were both teachers and passed on their skills with great dexterity, enabling pupils such as William Hughes and George Clare to make their names famous with this style of painting. This was the era when fruit was depicted by being placed within the confines of mossy banks and painted with an extremely light

foreground and a backdrop featuring one or two leaves among the moss.

George Clare and his two sons, Oliver and Vincent, concentrated on fruit and flower paintings in this style for their entire careers. Highly detailed fruit and baskets of spring flowers, with trailing sprigs of apple blossom and the like, would appear in these small consummate paintings. Redcurrants, blackberries, gooseberries, strawberries and a complete range of soft fruits were used to great effect. The bloom on the peaches and plums and added highlights on the grapes were strongly featured in the manner taught by Lance and Hunt. Fruit painted in this technique worked very well on a small scale and was to greatly influence the porcelain artists of the time.

Most of the well-known porcelain manufacturers had specialist fruit painters, and Aynsley, Derby, Spode, Doulton, Worcester and Wedgwood all featured fruit designs. However, it was to be the Royal Worcester Porcelain Company that excelled in this genre and made it their own Worcester style.

Worcester fruit artists of the 1920s produced work of such unparalleled beauty that today these pieces are snapped up around the world for astronomical prices. Such talent was exhibited by the Austin brothers, Reginald and Walter, and by Harry Ayrton, William Bagnall, John Freeman, Thomas Lockyer, George Moseley, William Bee, Horace Price, William Ricketts, Richard Sebright, Albert Shuck, Edward Townsend and Charlie Twilton. All of these professional ceramic artists continuously painted fruit, some to the exclusion of any other theme. Richard Sebright spent fifty-six years painting fruit and at the time was considered by his colleagues to be the best living fruit painter. Continuously depicting the same subject gives you the opportunity to perfect it and this, together with a love for the medium, places you high on the ladder to success. For any porcelain artist wishing to emulate the Worcester style, the study of these talented artists' work would be of great benefit. This type of art is extremely painstaking and requires much skill and fortitude, but the results can be very rewarding and there is a positive public that follows the pursuit of this technique.

We know from previous discussion that each artist has their own particular way of approaching fruit painting, and in the following instruction

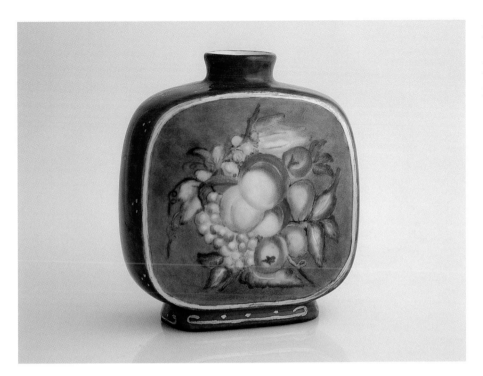

Small fine porcelain
bottle with blue
ground decorated
with gold and rose
panel. Front.

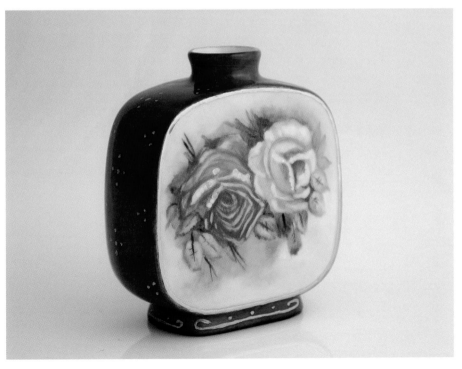

Small fine porcelain
bottle with blue
ground decorated
with gold and
naturalistic fruit
panel. Back.

159

Furstenburg porcelain pedestal vase with acorn lid, superbly decorated with freehand-painted fruit in mossy background, gilded with rich burnished gold.

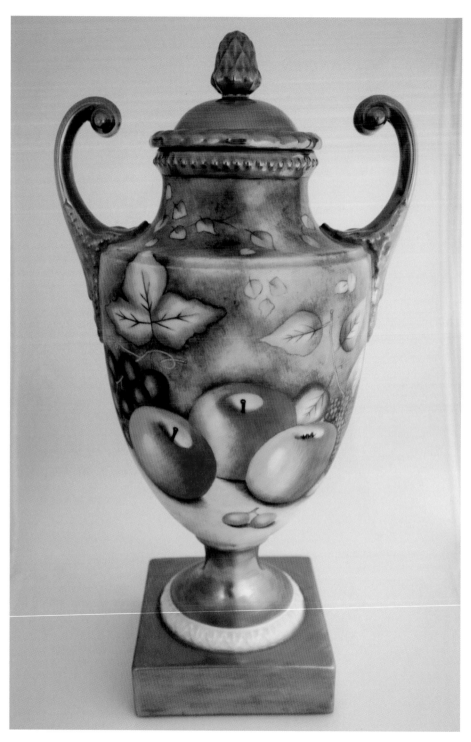

we shall examine certain methods and techniques. This includes the Worcester style, which dates back to the late 1700s and the time when most fruit painters adopted the 'mossy bank' composition, and was later developed by ceramic artists into the style we easily recognize today.

Guidelines for painting naturalistic fruit

The complete knowledge of colours and how they fire should be well established by now, and this experience will guide you when painting fruit. It is your first thin coat of paint that is most important: the various tones and colour have to be blended so that you can maintain a natural look.

As you are aware, some yellow destroys other colours, so choose those hues you have handled before and whose limitations you know. All indications of a bloom on whatever fruit is being painted must be considered and placed into operation on the first firing. That particular choice of colour is going to shine through at the end and give you the desired effect.

As you go along you will find that painting in a circular form needs to be practised. Brushwork and blending by stipplers and silk pad will be necessary.

Become familiar with your subject so that you know its idiosyncrasies. Apricots, peaches and plums have a distinct indentation line towards the centre of the fruit; this must be clearly and positively indicated. Oranges and lemons possess a textured skin – they are not smooth and shiny – so endeavour to show this by your stippler and silk pad. The bottom end of the lemon usually has a distinctive contour, so incorporate this unusual feature also. Cherries, however, are shiny and fine and come in different shapes and colours; they always have a strong highlight which is best retained by use of the white porcelain. Gooseberries appear with very fine lines and a little tail at the bottom; they are usually quite fat in shape and hairy, in various shades from green to greenish-yellow, pink and ruby. Blackcurrants are very round and have an extreme highlight, with a bloom on one side and a tiny red-brown tail, while blackberries are round but appear more squat in shape and show lots of highlights, elegant leaves and a pretty flower.

Apples and pears are among the favourite fruits to paint and occur in many shades of red, yellow, russet and green, with shapes that differ according to their cultivation. They usually have sharp highlights and need much shading according to their various colours. Grapes make exquisite subjects whichever way they are depicted, as a single hanging bunch or when placed strategically. They arrive in many colours, purple, red, green and white, and appear transparent, with distinct highlights and reflected light at the bottom of the individual grape. Strawberries have unusual shapes, some conical and others wedge-shaped, with a little green flower-like stalk at the top, and the

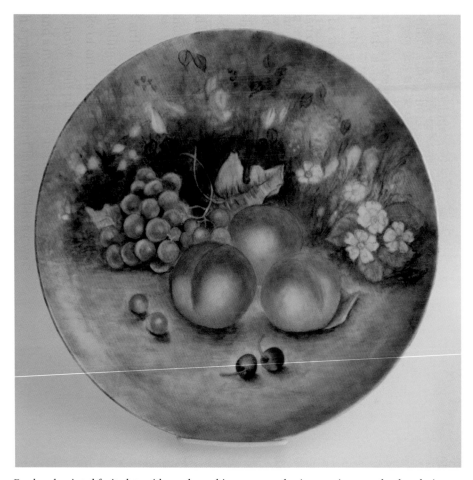

Freehand-painted fruit plate with peaches, white grapes and primroses in mossy bank technique.

centres show many highlights and indentations, with pretty fringed leaves.

Knowing your fruit before painting it is a great asset and will help you to perfect the correct look. This knowledge is essential as fruits are recognized by their individuality.

Unless you have set up a still life of your fruit on the table and are working from that, you will need a study or a good photograph. A hanging bunch of grapes requires to be well drawn, showing the various sizes and shapes of the rounds, with smaller ones appearing at the bottom.

- Lightly sketch your study on to your porcelain, or transfer it by way of a

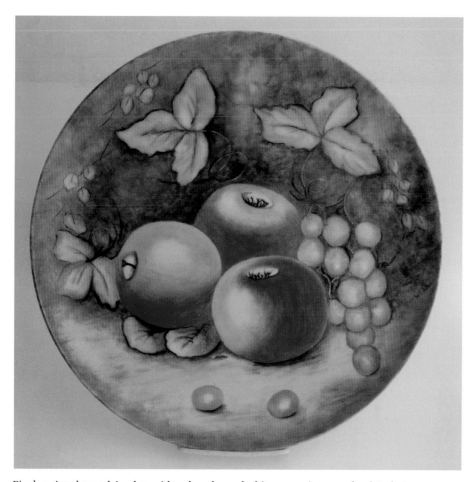

Finely painted porcelain plate with red apples and white grapes in mossy bank technique.

tracing. It would be advisable to start with a simple composition – an apple, pear and peach, a cherry or two, lots of rounds to get you painting in a circular fashion.

- Choose mineral colours that are closest to your study or follow the instructions given with your design. If your apple is red with yellow streaks, use egg yellow with yellow-red, and at the same time incorporate other red tones that might apply to match with your study. You will have to work these colours one into the other, so have more than one brush on the go, and your silk pad or stippler. It may sound complicated, but with practice you will soon achieve the desired result.

- Peaches are usually very pale with a rosy blush on one side. Use an ivory tint, the lightest in your range of colours, for the main part of the peach and at the same time work in the other colour that is featured, such as peach blossom or the like. This really is the time when your colour knowledge comes to the fore. If the fruit has certain blemishes that you wish to incorporate, lay these in as well as taking out your various highlights.

- For your first coat the fruit should compare well to your study. Establish as much detail as you can on the first firing. Remember that what you see is what you get, and do not fire anything if you are dissatisfied – remove the paint and try again.

- The leaves of fruit vary in colour: some are green, others yellow-brown. The variation is interesting and gives you an opportunity to use many shades, so do this in an artistic fashion.

- Fruits in the main are heavy, so do not have them floating around; a good coat of colour is necessary but must be delicately carried out.

- With respect to backgrounds in naturalistic fruit, it is important that you incorporate the colours already used. Do not introduce an alien colour for effect but pick a pretty tone from one of the fruits and blend it into the work as a whole. Make sure you do not detract from the main subject but have sufficient colour to sustain interest.

- If you wish to fire the fruit first and then add a background, that's fine.

In this way you can play around with the colours with ease, knowing that your fruit is safe. On the other hand, painting a background at the same time will save another firing, as long as you are confident to do this.

Chardin was known to say, 'We use colours, but we paint with feeling.' He was also quoted saying, 'Less is more.' If we keep these two thoughts in mind when setting up our porcelain still life, the results must benefit.

Fruit painting in 'mossy bank' technique

- This is an entirely different approach to fruit painting, and the ceramic artist needs much experience before tackling it. In the main it is totally freehand work, and the ability to sketch directly on to the porcelain is preferable and gives the end result a feeling of skill.
- You will need: a 10-inch plate or plaque so that you can work more freely; the following colours: light pink, dark pink, maroon, primrose or light yellow, deep yellow, various greens including chrome green, turquoise, baby blue, royal blue, black, rich brown, yellow ochre, golden brown, light red or a yellow-red, and turquoise; the medium of your choice; all of your brushes, plus a large mop-headed stippler; the usual pure gum turps, silk pads, etc.
- Be very organized when you attempt this method: you do not want to stop and start looking for missing equipment. Once you commence you need to keep your momentum and concentrate on the piece at hand.
- Draw your fruit in a good composition; include green and black grapes, a peach and an apple, two cherries. Behind the fruit, set up a well-shaped apple leaf and some peach leaves to harmonize.
- Commence with the apple, which is drawn bottom up. On the right-hand side, lightly apply the deep yellow to nearly halfway across, then continue with light yellow, working in a little shading green for the left side and bottom of the apple. With your brush, carefully cut out the paint from the stalk region and make your highlight; add the stalk at the same

Large Kaiser porcelain vase with freehand-painted fruit in mossy background technique, with lid gilded in burnished rich gold.

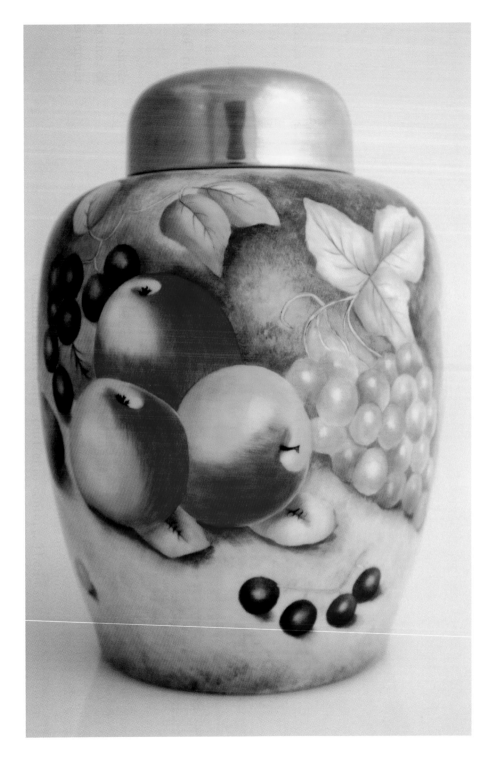

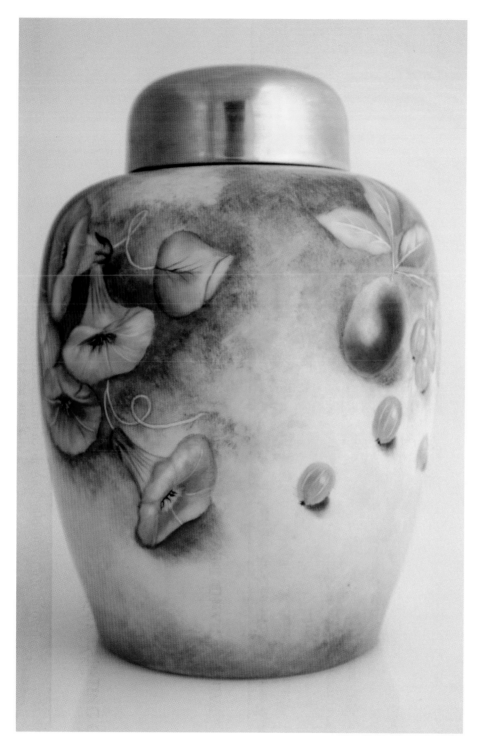

Back of large Kaiser porcelain vase with blue painted morning glory in background.

time. Pull out your highlight on the front of the apple. Treat the cherries as tiny apples and paint in the same way.

- Along the bloom side of the peach paint a thin coat of turquoise and a small amount of dark pink, and then gradually add your deep yellow, fading into your pale yellow. Do this also along the indentation of the peach, and add a little green once again at the bottom.

- Green grapes require a thin coat of turquoise at the top, coming down to the bottom with a thin coat of pink, and at the bottom of all the grapes a thin amount of lemon yellow. Make sure you pick out all the highlights in the grapes. Your first coat must look translucent.

- On the bloom side of the black grapes give a thin coat of the turquoise, shading in the light pink and dark pink, then take out the highlights in the grapes, always leaving a little colour whenever you do this.

- Paint in your leaves with a thin coat of the necessary colours, starting with pale lemon and shading into your green or autumn shade. Thin applications are necessary for the first coat on all fruits and foliage.

- Now you must start on your mossy background. With your large square brush, come into your fruit area with maroon paint in a light wash, and make a suitable background, working upwards. Do not cover the plate but leave various areas for the light yellow and green to be painted in with criss-cross brush strokes. With a small brush, pull out many-shaped tiny falling leaves and cut out the grape stalks, all from the wet paint. With your mop brush, carefully push down on the background to give a mossy effect. You must cover your foreground with the pale primrose or lemon, and shadows beneath all the fruit must be added with your maroon.

- Fire high.

None of this is easy, so if you are not happy with the result, remove it and start again. This type of work takes time to learn, but once you understand what you are trying to achieve it comes naturally.

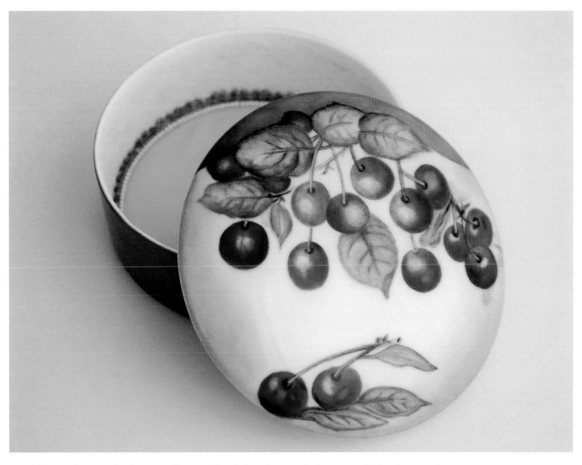

Round bone china trinket box, top decorated with hand-painted cherries and edge decorated in heavy burnished gold.

Second coats

- Starting with your apple, shade yellow-red or red (the one that you are familiar with) over the deep yellow, allowing a minute amount at the very edge to show through, and continue with this until you reach the area that is to be yellow. Now blend the deep yellow and some more green to shape the fruit. Work on the stalk and make sure there is a nice indentation at the top.
- With the peach, care must be taken to cover the turquoise with just

169

enough pink to allow the bloom to show through, and shade it darker as you go into the yellow. Make sure the deep line on the peach has bloom also.

- The green grapes are carefully covered with chrome green, leaving the pink and yellow parts in the same shades, only strengthened. Keep your highlights.
- Purple grapes can be painted in a mixture with the bloom carefully retained and the centres a lighter pink, with the highlights removed in the usual manner.
- Carefully paint the leaves and make them sit at a good angle to accommodate the fruit. Repaint the foreground and put shadows under the fruit, making sure the light area is just that. Now work on the mossy background again, making it look interesting and attractive. Continue in this fashion until you are happy with your result.

As you develop your style in this technique you can include a flower from the fruit, or place various effects in the foreground, and put your very own individual stamp on the work.

APPENDIX

Helpful organizations

There are some very interesting and invaluable organizations for the porcelain painter to become involved in if he or she so desires. For those who have a computer and are online, there are specific sites full of information, and visual beauty. The two major organizations that promote the fine art of porcelain painting are based in the USA: International Porcelain Artists and Teachers, Inc., widely known as IPAT, and the World Organization of China Painters (WOCP). Magazines published are *Porcelain Artist* and *The China Painter*, along with *The China Decorator*.

In addition there is Porcelain Painters International Online (website: www.porcelainpainters.com). You will find all the addresses and necessary information for china/porcelain painting studios and stores throughout the USA and worldwide. The site is crammed with information, a must for all porcelain artists and those interested in the art.

IPAT Inc. (website: www.ipat.org) is a non-profit organization chartered in Texas in 1962. It is made up of more than three thousand porcelain painters in approximately fifty countries all around the globe, and maintains a corporate office and a museum at 204 East Franklin Street, Grapevine, Texas.

WOCP Inc. (website: www.theshop.net/wocporg/) was chartered in 1967 to educate people in the fine art of porcelain china painting. It also has a museum, open to the public, at 2641 NW 10th, Oklahoma City, OK 73107-5400.

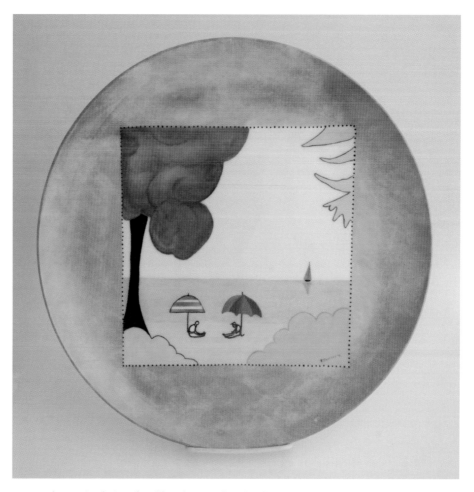

Happy Plate series designed and hand-painted with yellow lustre surround with black enamel dots and beach scene.

The China Decorator magazine (website: www.chinadec.com) was founded in 1956 and fashioned on an original magazine that was published from the late 1800s.

The Scottish China Painters' Association (website: http://www.scottishchinapainters.co.uk/page1.php) was formed in 1981.

Westfield House China Painting School (website: www.westfield-house.co.uk) runs residential courses in Yorkshire and produces *The British Porcelain Artist Magazine.*